D1434024

HARRY HOLLAND

THE PAINTER & REALITY

EDWARD LUCIE-SMITH

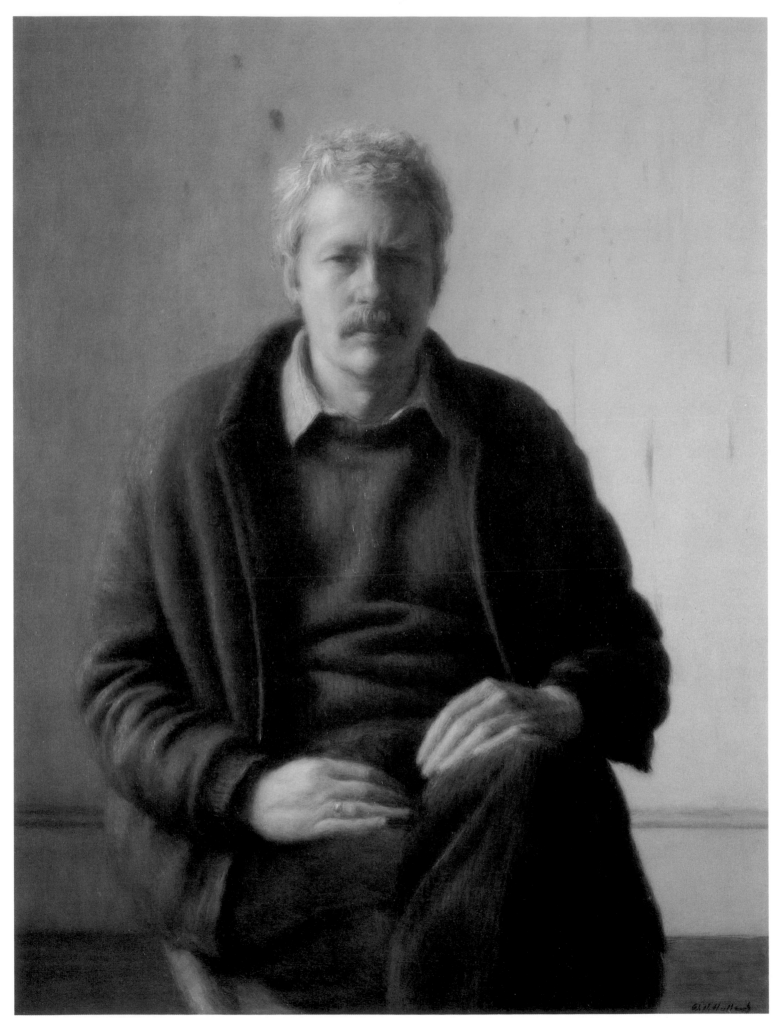

Self-Portrait. 1987. Oil on panel. (Newport Museum and Art Gallery)

HARRY HOLLAND

THE PAINTER & REALITY

EDWARD LUCIE-SMITH

ART BOOKS INTERNATIONAL
LONDON

British Library Cataloguing in Publication Data
Lucie-Smith, Edward
Harry Holland : the painter and reality
I. Title
759.2929

ISBN 0–946708–22–3

First published in 1991 by
Art Books International Limited
1 Stewart's Court
220 Stewart's Road
London SW8 4UD

Typeset in Great Britain by Saxon Printing Limited, Derby
Printed in Singapore

CONTENTS

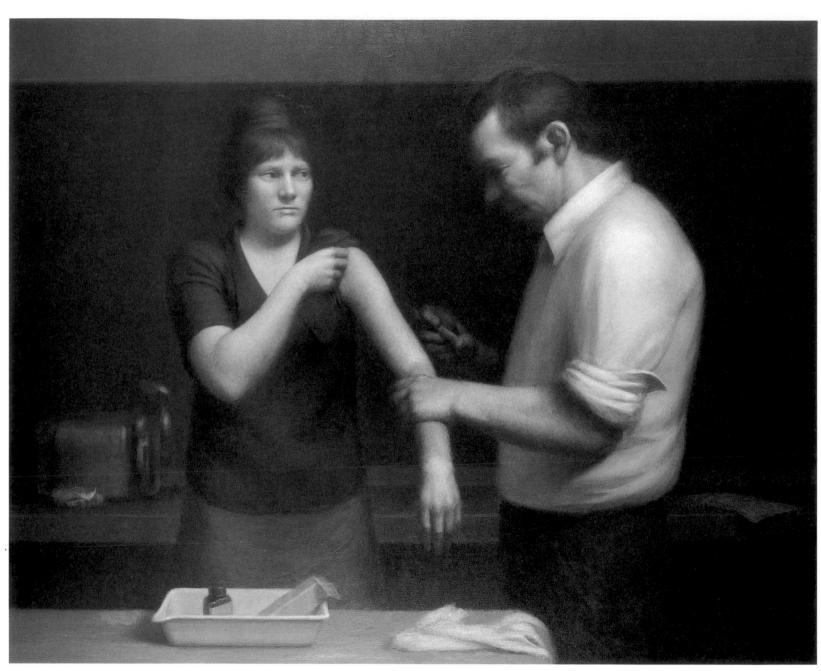

1 *Company Doctor*.
1979. Oil on canvas.
(Private collection)

1

Of all the categories into which western painting is traditionally divided, still life presents the most difficulties to the critic – that is, to the person who tries to analyse visual images and transfer them to a different medium, that of words. At the same time, a successful still life often seems the most complete and perfect demonstration possible of what the art of painting can do, of the things which make it different from the other creative arts. Sir Ernst Gombrich, one of the subtler explorers of this topic, once cited the Chardin of a vase of flowers, now in the collection of the National Gallery of Scotland, as perhaps the most "perfect" painting he knew, simply because it is so entirely self-sufficient, so complete in itself, so free of outside references. It was, he said, impossible to produce a verbal equivalent.

This book describes the work of an artist who is predominantly, especially in his recent work, a still life painter. What Harry Holland does raises a large number of questions about the way in which painting functions, and suggests unorthodox answers to at least some. It also asks questions about the nature of Modernism. To these, for the most part, no absolutely definite reply can be given, and this uncertainty is symbolic of the situation now occupied by the Modern Movement as a whole.

The paintings brought together here have another function, of an almost moral sort. They demonstrate how, in 20th century art, what may seem marginal is often constantly on the move towards the centre. Artists who, when first encountered, appear to be outsiders, not closely linked to the major artistic preoccupations of their time, move almost stealthily towards the middle ground, and then at some point are suddenly hailed by historians as seminal figures, possessed of wide influence. Two recent examples of this phenomenon are Balthus and Lucian Freud. Fifteen years ago, both of these painters, though admired by a small group of connoisseurs, seemed stylistically isolated. Neither had played a role in the major artistic movements of the century. Neither seemed to exercise much influence over painters younger than himself. Thus, while the skill of each was rather grudgingly acknowledged, both tended to be regarded as anachronistic. Today the situation has completely changed. The work of Balthus and Freud preoccupies not only leading critics, but other artists, and the current of development now seems to flow through, rather than round them.

These two painters offer a significant example here for more reasons than one. What they have in common is the fact that they are figurative artists of a traditional

sort, technically conservative. What makes them seem unmistakably contemporary is not technique, nor even subject matter, but sensibility – a psychological aura, hard to define but immediately recognisable, which tells us that these paintings could not have been made at any other moment in the history of post-medieval civilization. Harry Holland's work partakes of the same atmosphere.

One of the things which fascinates me about the development of the figurative painters of the present time, so-called traditionalists perhaps most of all, is the fashion in which this reverses expectations. The initial "outsider" status of these artists is generally confirmed by their professional biographies. Often they have been slow starters, finding their way by fits and starts to what they wanted to do. This is certainly the case with Holland. It is true that he says, when the subject of his development comes up: "I never had any problems about being a painter – it was something I always did." This, however, is immediately qualified by a remark about his early days at art school: "I wasn't good at painting – I've never been good at painting. What I'm good at is copying things – good at making something look like what I see. One of my great delights has always been copying drawings and paintings. I am convinced that I could have been one of the best copyists in the world." A comment of this type would have come very appropriately from a leading pupil at the Carracci Academy in Bologna, in the earliest years of the 17th century. It sounds a little strange from the lips of a contemporary artist, after almost a century during which the idea of "copying", in all its guises, has been aesthetic anathema.

Holland is prepared to elaborate on all this. The point about making a copy, he says, is that you are dealing with "something you can know about. When you're painting something interior to you, there is so much you don't know about – you're swimming around. I'm always trying to be certain about things. The business of swimming around is very productive, but I don't actually enjoy it."

The force of these remarks is confirmed by the pattern, or lack of it, in his early career. Holland cannot claim to have developed swiftly. It took him the best part of two decades to arrive at a personal and independent style. This struggle for personal identity was conducted, perhaps fortunately for him, within the boundaries of the British art-school system. The story tells us something about the virtues and deficiencies of British art-education as this existed during the 1960s and 1970s, a period which many people connected with art teaching in Britain now consider to have been a kind of golden age – for those who taught, if not for their students.

Holland did not find it easy, in purely practical terms, to make a career as an artist. His first attempt, without grant aid of any kind, was at Wimbledon College of Art. It collapsed for lack of money, and he was then forced to become a student at a commercial college. This wholly failed to satisfy him. "I kept", he now says, "coming back to the central thing." He returned to art studies, now equipped with the necessary grant, at St Martin's in London in 1965.

His reactions to these early studies are significant. He enjoyed the Foundation Course because its emphasis was on practical skills. He did not feel at home with the

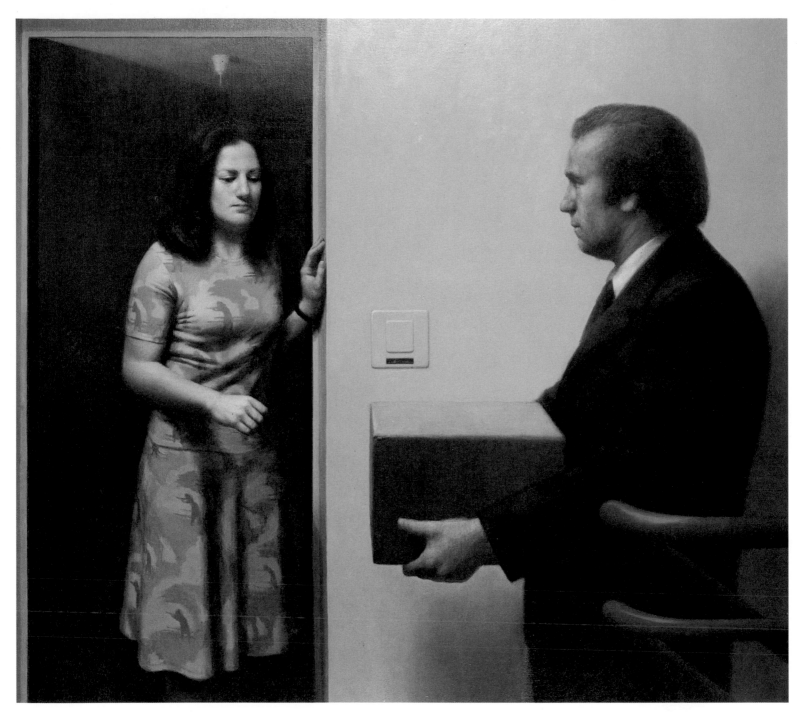

2 *Breadwinner*. 1978.
Oil on canvas.
(Contemporary Art
Society, Wales)

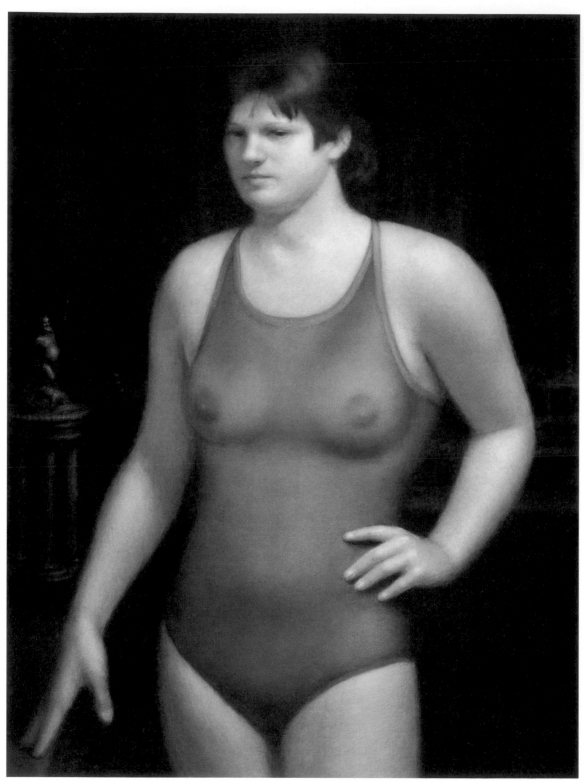

3 *Champion*. 1980. Oil on canvas. (Private collection)

conceptual and theoretical studies he was later asked to pursue. These conceptual studies were in the process of being re-emphasised because British art was then at a stylistic turning point. "Pop Art was still in full swing but the art-college intellectuals were mostly making abstracts . . . They were talking about things which didn't seem to have any real relationship to the thing itself. I couldn't cope with that because I actually loved objects."

He nevertheless graduated successfully from St Martin's, and his first job after he left brought him experiences which were perhaps as significant as anything he learned while he was still a student. He started to teach for a day a week at the Chelsea Community Centre. Here the students, a wide social mix, "from dukes to dustmen", were all amateurs, working in their spare time. "What I found very revealing was that for these people art wasn't a game – which it had sometimes seemed to be at St Martin's. These people were totally committed to their activity. They knew that there was, quite concretely, a world of beauty and a world of art. They wanted to attach themselves to it and contribute to it."

The job, which in fact lasted for only six months, was the first of a succession of teaching posts, a career-pattern typical for almost all artists in Britain at that time. Holland went first to Coventry, one of the more consciously "progressive" out-of-London art colleges. According to his recollections, the staff were divided between artists – painters and sculptors – who made use of traditional formats and means of expression, and a group of tutors who were impassioned adherents of the new Conceptual Art, which had made its appearance in the United States in the mid-1960s, and which had soon spread to Europe. Joseph Kosuth, the American-Hungarian pioneer of the Conceptual Movement, made appearances at Coventry, where the intellectual wing was triumphant throughout Holland's period on the staff.

His reactions to the situation in which he found himself are perhaps unexpected, in view of his temperamental sympathies, and the direction taken by his own work. "What it really taught me was that artists need to take sides. And at that time my heart really went out to the Conceptual guys. First of all, I thought they knew something I didn't. More, they were expressing what they believed in with passion and a degree of poetry – even beliefs which now, in hindsight, seem to make no sense at all. I preferred it when they talked to when they wrote, because that was when the passion came through. I remember when the word 'hermeneutics' hit Coventry. It immediately appeared in every conversation – not necessarily with its correct, dictionary meaning, but in such a way that it was charged with all sorts of meanings. I loved that, because I like poetry. What I learned at Coventry is that artists have to have a hero – you're lucky or not in the guy you choose to follow."

It was during his period at Coventry that Holland first started to exhibit his work on a regular basis, though without any real enthusiasm for the activity. "The reason I showed," he now says, "is that you couldn't really be an artist unless you did."

He left Coventry College of Art in 1972 and then taught at other Midlands art colleges until 1974 when he moved to Cardiff. He was invited there by colleagues

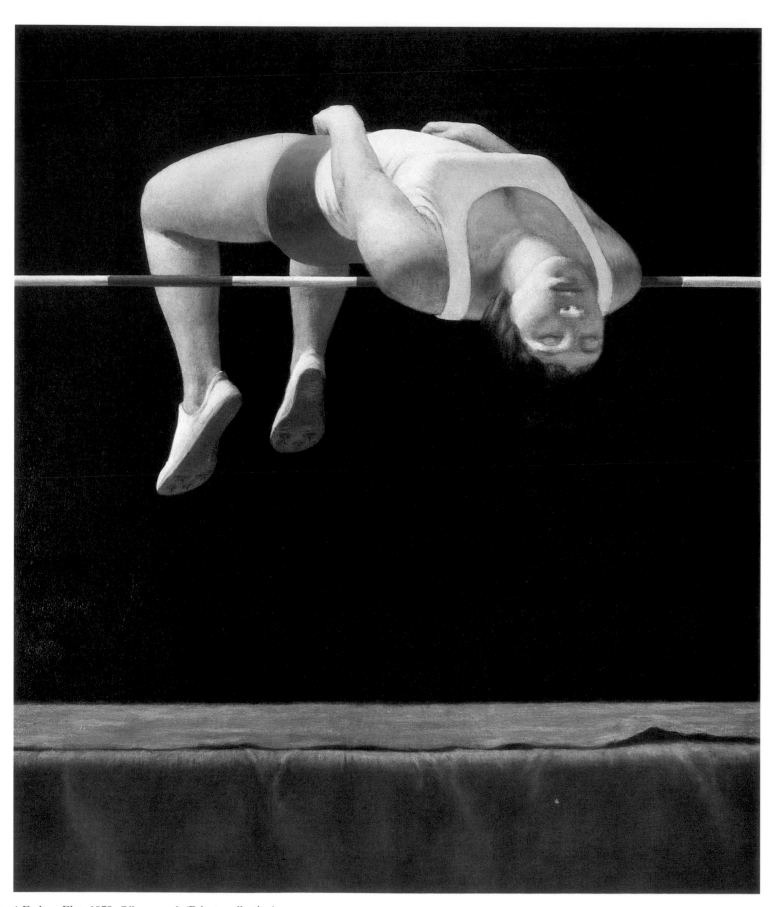

4 *Fosbury Flop*. 1978. Oil on panel. (Private collection)

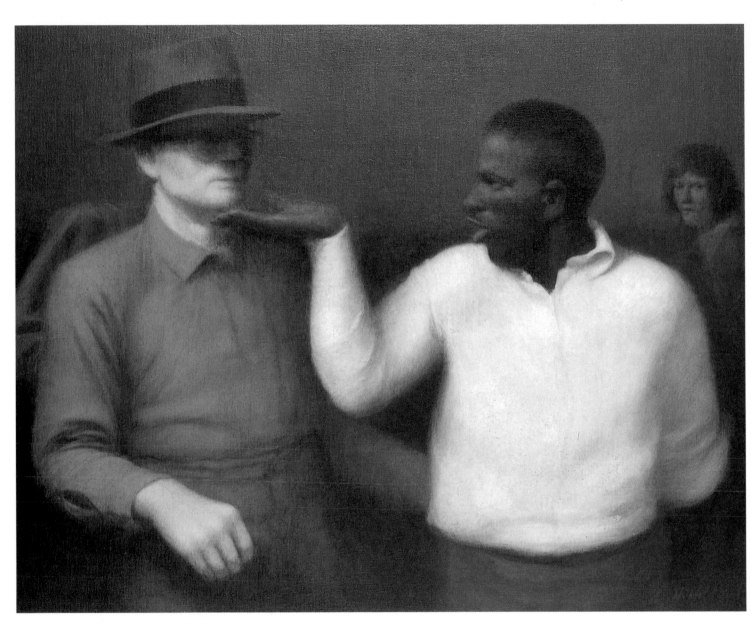

5 *Pickpocket*. 1979. Oil on canvas. (Private collection)

with whom he had already worked in Coventry. His five-year stint at the Cardiff College of Art marked the end of his career as a teacher. Since his resignation in 1978 he has been able to paint full time.

An episode which belongs to his period of teaching at Coventry was the purchase of a large block of Holland's paintings for the Saatchi Collection, then in the earliest stages of its formation. None of these purchases appear in published Saatchi catalogues, and the artist believes that all the paintings have now left the collection. "I think I simply became less interesting to him (Charles Saatchi) – and I think, looking at the work of that time, quite rightly so." He remembers one conversation with this patron with affectionate amusement. "He said to me 'You should be a star!' With my Marxist leanings at that time this was of course totally antipathetic to me. But I took the money and bought a car." The relationship seems to have marked a psychological turning point, if not an artistic one.

If the connection with Saatchi proved to be a dead end, another bond formed at this period was more important. Holland began to exhibit work with the Nicholas Treadwell Gallery in London. Its proprietor was extremely successful in marketing his work, finding an audience for it which was often outside the known circle of art collectors. The earliest paintings illustrated in this book, and thus the earliest the artist fully acknowledges, are among those which passed through Treadwell's hands. The association played a major role in convincing Holland that he ought to commit himself to painting full time.

Nevertheless the Treadwell Gallery, though reasonably centrally located in London from a purely geographical point of view, occupied an isolated position in all other respects within the London art world. With a policy largely slanted towards Photo-Realism, a style which was, and remained, beyond the pale as far as most British reviewers were concerned, it experienced greater difficulty in attracting critical attention than in selling art works. Holland therefore became successful, at least from a purely material point of view, with little change in the outsider status which had been his throughout his career.

After leaving the Nicholas Treadwell Gallery he went first (1983) to the Ian Birksted Gallery in London, then joined the Thumb Gallery in 1986, now (1991) renamed after its owner, Jill George. Jill George has been successful in moving Holland's career towards the mainstream, and, in particular, has brought him a number of enthusiastic overseas collectors, particularly by showing his work at leading American art fairs.

His collectors now cover a wide range. His early contact with Saatchi was prophetic in one sense at least – his work has continued to attract people who work in the advertising industry. There are also lawyers, accountants and successful business people of all kinds – a contemporary mirror image of the kind of clientele who might have purchased a successful Dutch still life painter such as Willem-Claesz Heda in the mid 17th century. In addition there are a large number of buyers from the creative world – film, pop music and television people, and also writers. These are perhaps the buyers whose interest he finds most stimulating.

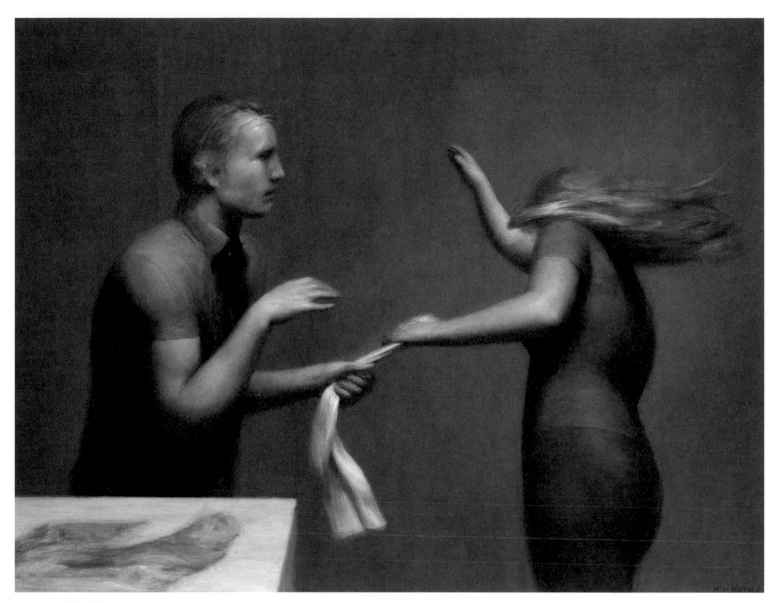

6 *Scene*. 1980. Oil on
canvas. (Private
collection)

The work of Holland's first phase is realistic, but not Photo-Realistic in the sense in which this term is usually employed. He was to show more awareness of the special vision of the camera at a slightly later date. The models he mentions for these paintings of the late 1970s and early 1980s are American, but belong to an older tradition. The names he cites are those of Thomas Eakins, George Bellows, Edward Hopper and Reginald Marsh.

It is easy to see the link with both Eakins and Hopper. A painting like *Company Doctor* (1), for example, can be seen as a much less ambitious equivalent of Eakins's celebrated *The Gross Clinic*. The deliberately weighty forms, with their matt textures and blunted edges, are also reminiscent of Hopper's figure paintings. This can be said of another two-figure composition, *Breadwinner* (2). What Holland and Hopper also have in common here is the element of narrative. A simple, clearcut action is taking place. One figure – the male – is the initiator, and is dominant. The female reacts to what the male is doing. It is only at this very early period that the relationships between the figures in Holland's paintings are so unambiguous.

Two other early paintings, *Champion* (3), and *Fosbury Flop* (4) show single figures of athletes – one in repose, one (a high jumper) in the midst of an action. These paintings can perhaps be referred, in a rather general sense, to Bellows's paintings of boxers in action, or to pictures by Eakins which depict boxers and wrestlers.

There is also another, and more immediate comparison available. These paintings by Holland are quite strongly reminiscent of certain Russian Socialist Realist works. Socialist Realism has acquired such a bad name in the age of perestroika that it is difficult for any critic – certainly any western critic – to admit that at least a handful of good pictures were produced under its aegis.

Fosbury Flop suggests a comparison with the later work of the leading Soviet painter Alexander Deineka, produced in the 1930s. *Champion* seems even more Soviet because it conforms to an established Russian pictorial archetype – that of the single iconic figure who serves as the representative of a whole class or group of people. Figures of this sort were already being produced in Russia by members of the Itinerant Group during the late 19th century. Well known examples, at least in Russia, are Ilya Repin's *The Archdeacon* (1877), Nikolai Yaroshenko's *The Girl Student* (1883) and Mikhail Nesterov's *The Hermit* (1888–89). Though the depictions are naturalistic – more naturalistic than

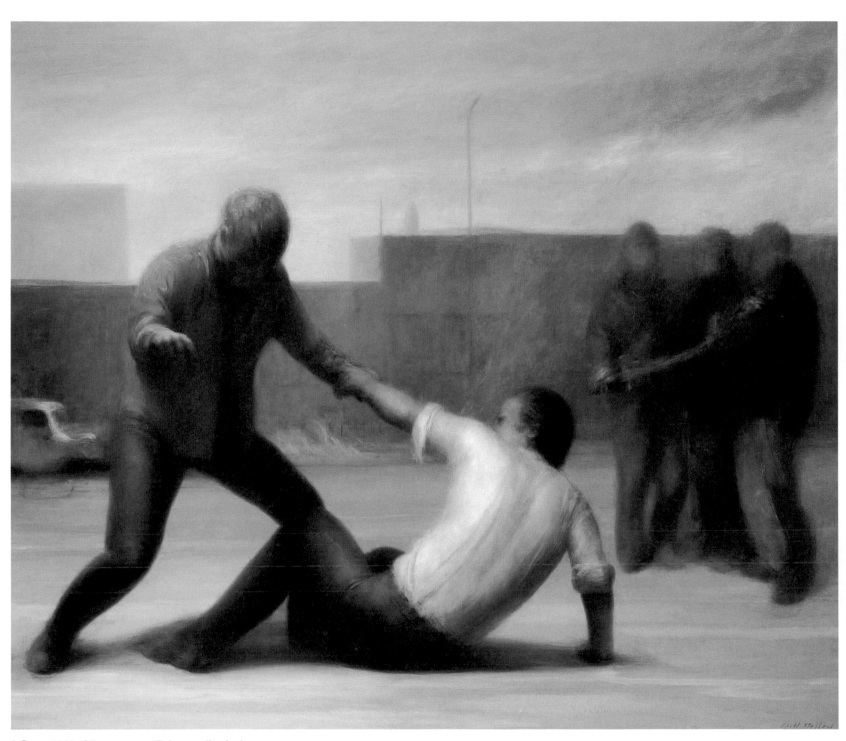

9 *Street*. 1983. Oil on canvas. (Private collection)

Champion – the type reaches back to traditional icons showing single figures of saints. Soviet paintings of this type very often depict athletes, as representatives of the new physical, materialist society: religious values are thus neatly inverted.

It is worth noting not only Holland's own declared Marxist sympathies at this point in his life; but the fact that his father, killed in a construction site accident during World War II, had been a convinced Communist who fought in the Spanish Civil War.

What is perhaps the most successful painting of this early group, *Pickpocket* (5), possesses a more complex art-historical pedigree. Low-life subjects of this kind, with life-size, half length figures pushed close to the picture-plane, appear suddenly in European art just before the year 1600. Among the earliest are some painted by the Late Mannerist Bartolommeo Passarotti in Bologna. More celebrated, but slightly later, are some paintings by the young Caravaggio, such as *The Fortuneteller*, now in the Louvre. Holland's reference to this tradition may be inadvertent, but it is worth noting that he rediscovered the work of the Old Masters at precisely this moment in his development. "Many of them," he says, "were as radical for me as a lot of the painting which was going on around me."

The figurative works which followed fall into linked groups. There are those which are primarily concerned with narrative; those which are chiefly focussed on depictions of the nude; and those where nudes are put into a narrative context.

An early example from the first category is *Scene* (6), painted in 1980, and thus more or less contemporary with *Company Doc-*

tor, The Parcel, and *Pickpocket*, all of which it resembles. What singles it out is the ambiguity of the action. It is difficult to tell, for example, if the woman on the right is jerking sideways to avoid an anticipated blow, or if she has already been struck. *Two Women* (7), from the following year, is less violent in atmosphere, but the actions and attitudes are still more difficult to construe with any certainty. This is also the case with another painting of the same title, which dates from 1983 (8). Here the figures seem to be reacting to some kind of threat, which may originate from where the spectator himself (or herself) is standing.

The atmosphere of threat is intensified in *Street* (9), of 1983, but here, as the artist himself points out, the ambiguities become more complex still. The group in the foreground may show one man threatening another, who tries to push him away; or else the subject may be one figure pulling the other by the arm in order to help him to rise.

Paintings in this group tend to have specific settings – for example *Corridor* (10), where the location is made obvious by the presence of a counter or reception desk. Typically, however, locations as well as actions are transitional – in terms of action, the artist concentrates on a gesture which is unresolved and about to flow into another; in terms of location he prefers places like streets, corridors and foyers which people move through en route for somewhere else.

Another characteristic is that one figure is often concealed from the others. *Family* (11) of 1986 is set on the top, uncovered deck of a multi-storey car park. A woman, a child and a large dog wait for a man – by

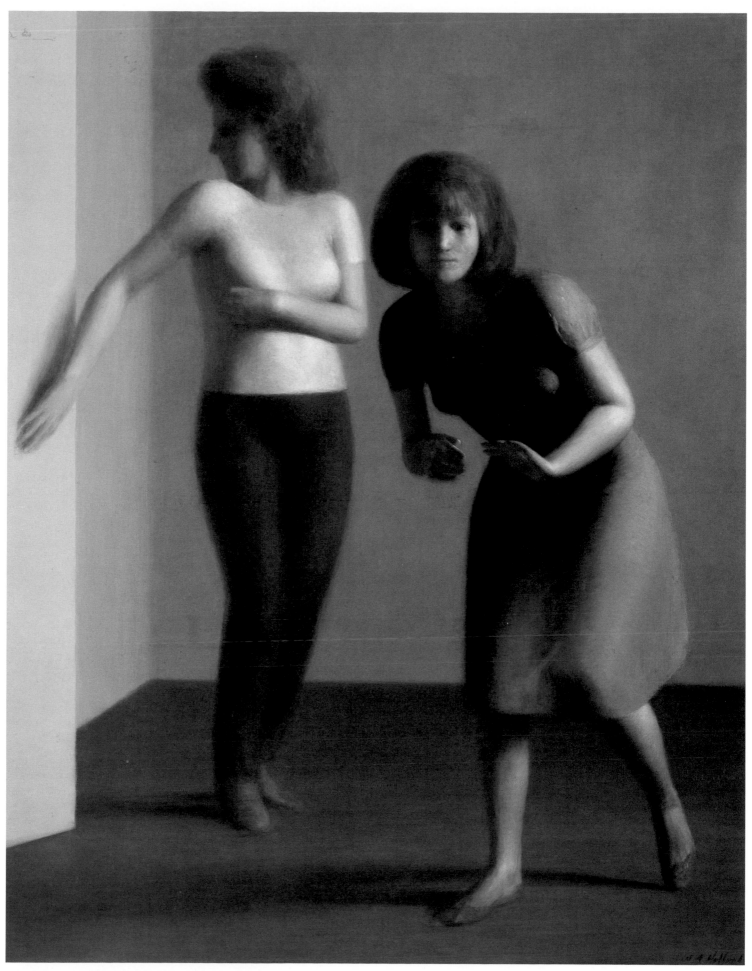

8 *Two Women*. 1983. Oil on canvas. (Private collection)

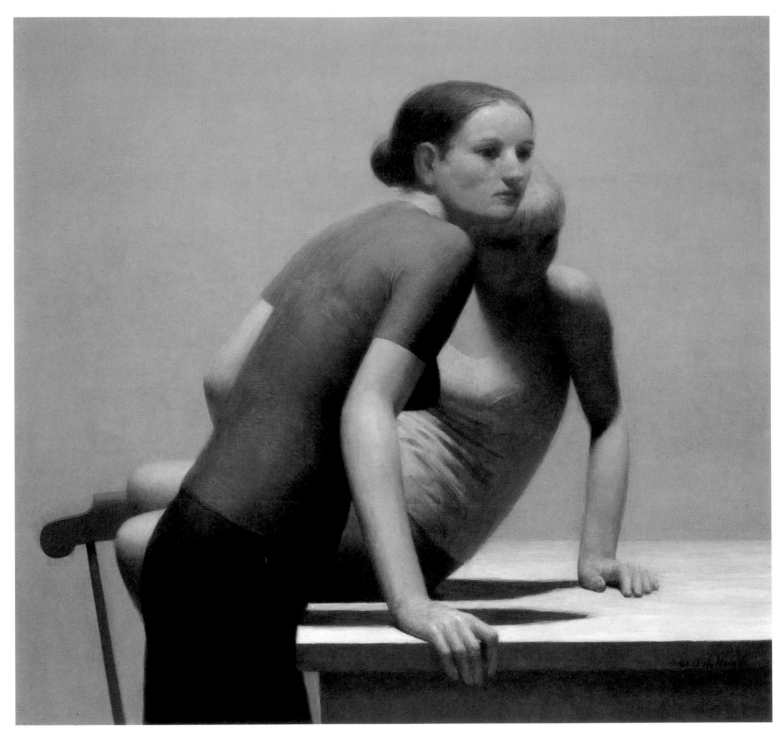

7 *Two Women*. 1981. Oil on canvas. (Private collection)

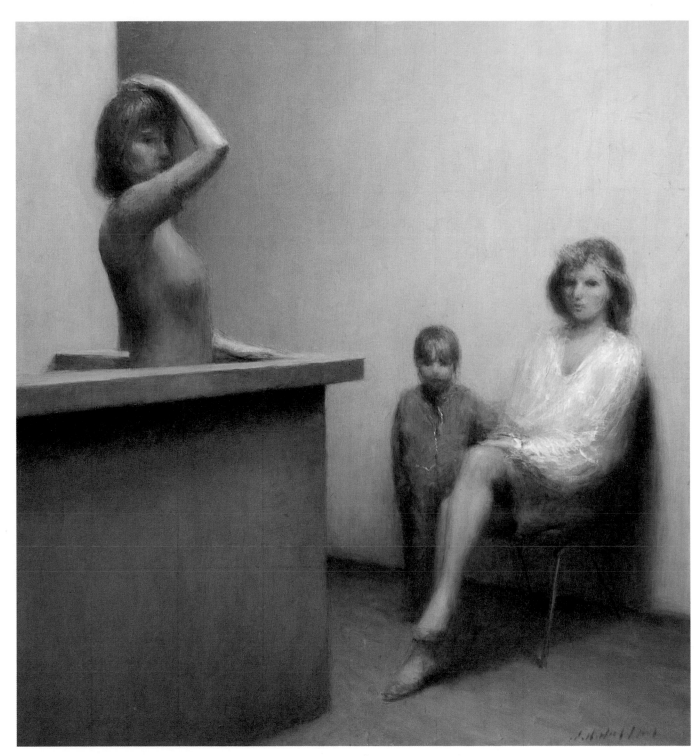

10 *Corridor*. 1984. Oil on panel. (Private collection)

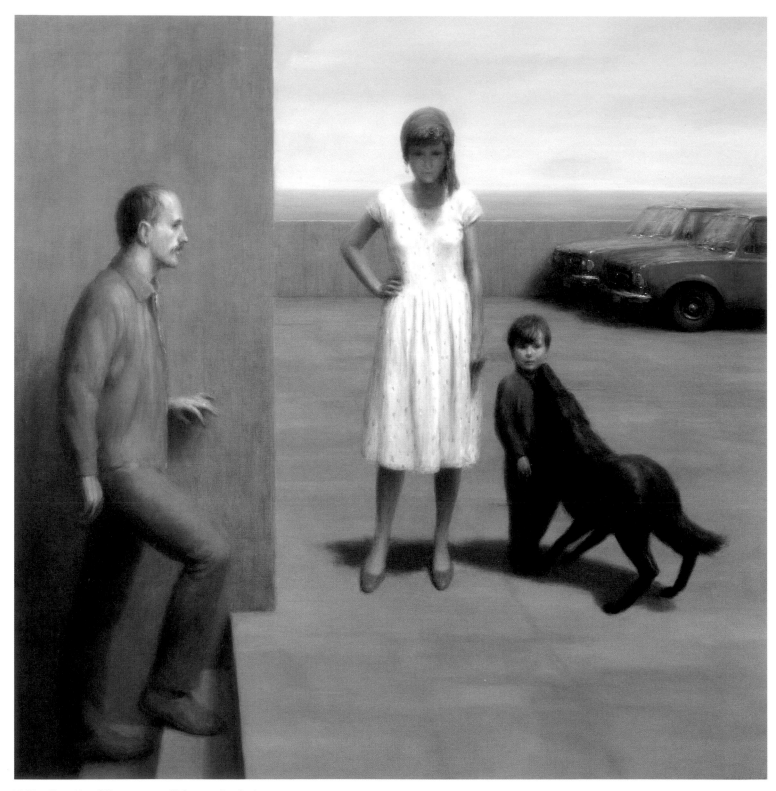

11 *Family*. 1986. Oil on canvas. (Private collection)

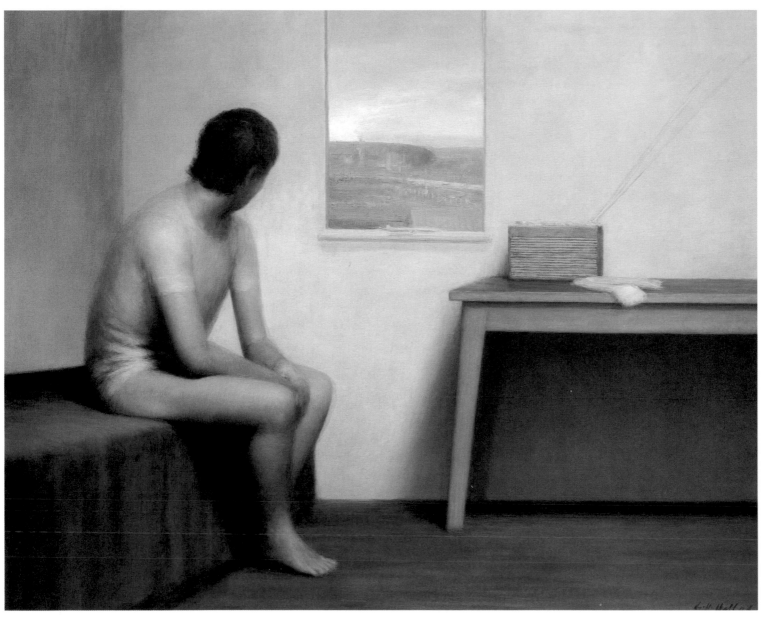

12 *Turin*. 1986. Oil on canvas. (Private collection)

24

implication the husband and father – who climbs a staircase on the left but who is still hidden from them by a wall. They are waiting to react, but have not as yet begun to react – we do not know what form the reaction will take. The composition, delicately, hints at the strains inherent in ordinary family relationships.

A fine painting, *Turin* (12), dating from the same year, further develops the theme of travel (which may be one of the things Holland has taken over from Edward Hopper). Here there is only a single figure, seen in what is obviously a hotel room – a room whose extreme bareness (the visible furnishings are a narrow single bed, a plain table and a portable radio) suggests purely temporary occupation. The figure, gazing out of the window, projects his thoughts into the far distance; he is there in body, but not in spirit.

Turin is significant in another respect. The figure is only partly clothed – he seems to have paused in the midst of dressing. The fact that he is half-naked links the painting to the long series of nudes which Holland produced during the early and middle 1980s.

Sometimes nudity is linked to a narrative situation of some sort – often ambiguous and perhaps slightly sinister. In another version of *Family* (14) we see the same three figures – two adults and a child – as appear in the other version of the painting, just described. The setting also seems to be identical – the top deck of a multi-storey car park, though the identifying vehicle in the right background has been removed. While the father and mother are still clothed, the little girl is now naked. She jumps up (though turning her head away slightly as she does so),

apparently so as to take some small object the father holds playfully above her head. The implications of her public nudity and of her relationship with the two adults are disturbing, most of all because all this seems to be happening in a public place.

Though the setting seems more private, there are also strange undertones to *Biko* (15). This also contains three figures, all male. A nude black sits on a plastic and metal chair. In front of him kneels a Caucasian, fully clothed. This figure turns, apparently interrupted in what he has been saying to the play. Behind the chair stands another white male, bare-chested, but wearing trousers and shoes. He is holding a towel, which he seems about to drape over the black man's shoulder. The title suggests an association with the black anti-apartheid leader Steve Biko, murdered by South African police in the 1970s, but the atmosphere of the painting is not violent. The black man at its centre almost seems to be enthroned – a ruler passively awaiting the attention of two subordinates. What contradicts this, however, is the fact that he is unclad, which in the circumstances might symbolize powerlessness.

A group of paintings of female nudes introduces a theme which has obviously fascinated the artist, as is proved by the number of variations on the same theme which he has produced. The generic title which he has found for the group is *Homage to Electricity*. Each painting features two figures. In some (96, 97), the women appear to be jointly concerned with changing a lightbulb, though the gestures are ritualized and slightly improbable. *Homage à l'éléctricité* (17), for example, ple, shows two women and the top part of a standard lamp. One stands over it, using a

13 *Beach*. 1985. Oil on canvas. (Private collection)

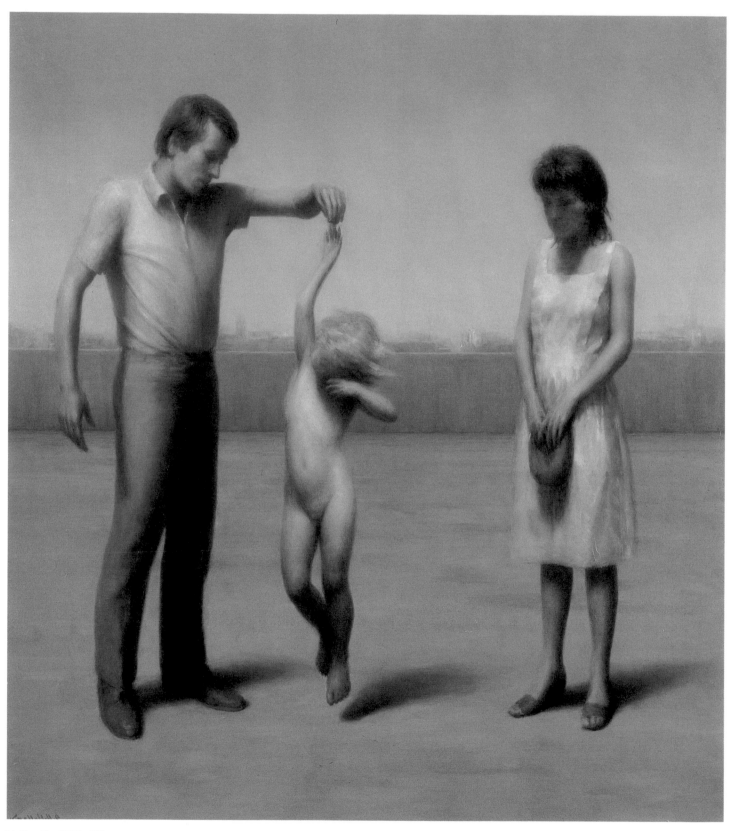

14 *Family*. 1985. Oil on canvas. (Private collection)

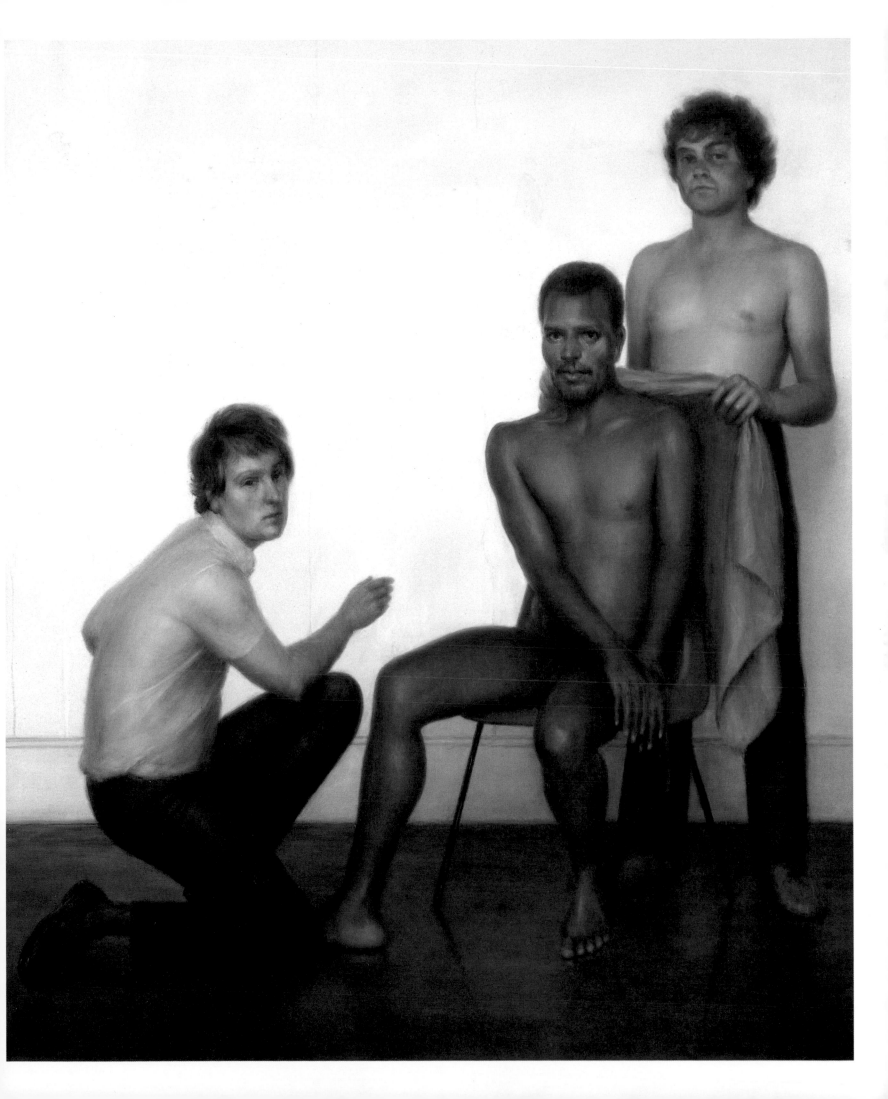

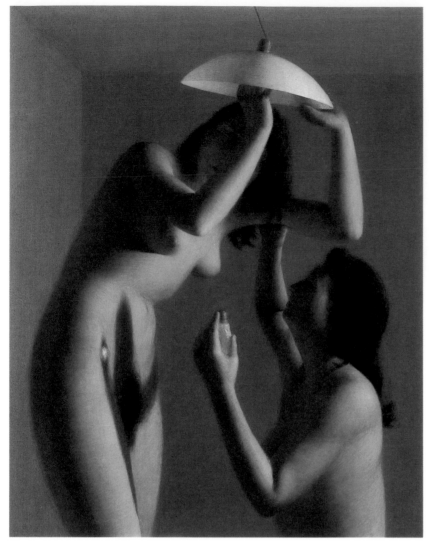

16 *Homage to Electricity*. 1980. Oil on canvas. (Private collection)

chair or other object (this cannot be seen, as it is cut off by the lower margin), while the other steadies it. She reaches up with her free hand, apparently to receive something from her companion – perhaps the bulb. But this is not in fact visible.

In another painting from the series (18), the source of light does not form part of the composition. One nude leans back against a table, shading her eyes with her hand; her companion bends forward and gazes at her intently, her head turned away from the spectator.

What the series does is to play with ideas about "seeing" and "being seen". These are taken up in different forms in pictures which portray nudes who are being photographed. In one, a fully clothed male photographer bends over his tripod,

focussing his camera on a female nude seated against a wall in a bare room (19). In another painting (20), an androgynous figure, clad in a kind of one-piece tracksuit or overall, points a hand-held camera at a nude couple – the woman clings to the man, who seems reluctant to respond. Obviously these two paintings contain a strong element of voyeurism – that is, the voyeurism of the spectator, and that of the artist, is mediated by the presence of the figure with the camera. The fact that the second of these paintings is called *Car Park*, links it directly to the two pictures called *Family* already described. The implication is that this event, too, is taking place in public.

The idea of the mediated vision recurs even in works where the nude is absent - for example in *Gallery* (21), where a woman gazes at herself in a mirror, apparently registering shock, and is watched as she does so by two men who seem alarmed by her reaction. Here we have entered the world of Kafka. The purely erotic element is less obvious, though it does remain as a kind of sub-text in the composition.

All of the nudes so far discussed have a semblance of narrative context; and in all the paintings the setting is by implication, and sometimes quite directly, thanks to the presence of certain garments and props, contemporary. Holland's discovery of the great painters of the past also led him to make direct paraphrases of their work. Yet even here the contemporary element intrudes. In *Ganymede* (22) a nude boy approaches a mature male with a tentative, submissive gesture, touching him on the shoulder. The man, who is clad in modern dress – jeans and a t-shirt – also sits on a recognisably modern chair. He ignores the

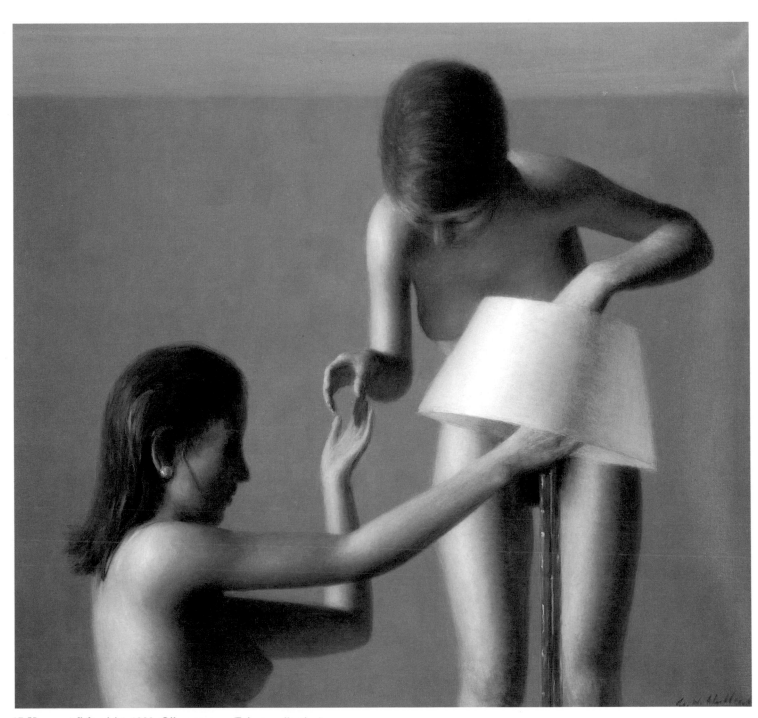

17 *Homage à l'éléctricité*. 1980. Oil on canvas. (Private collection)

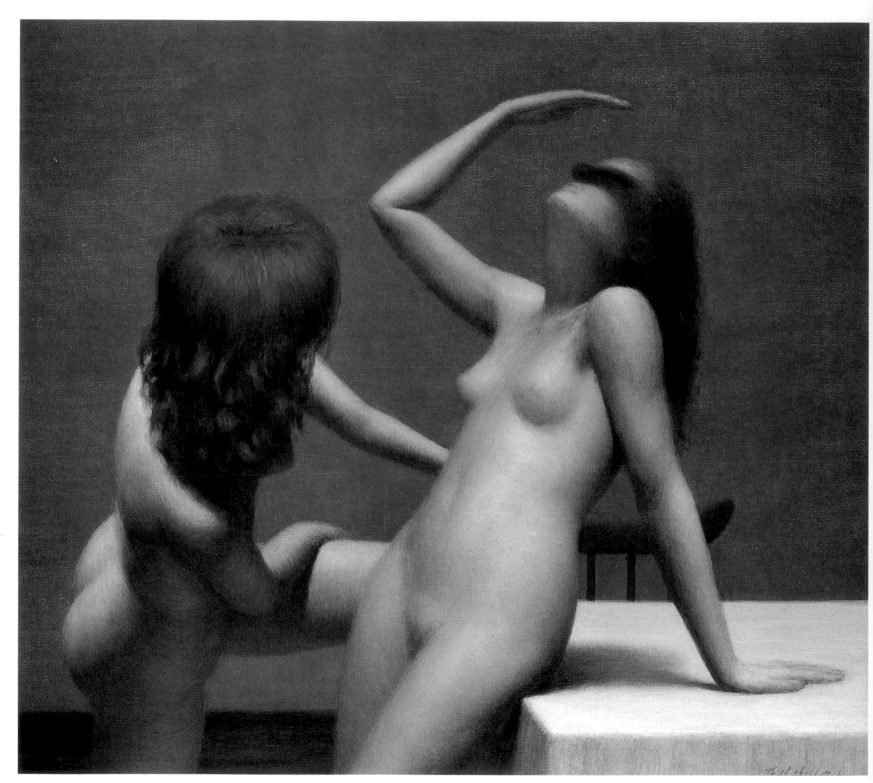

18 *Omaggio a l'electricidad*. 1980. Oil on canvas. (Private collection)

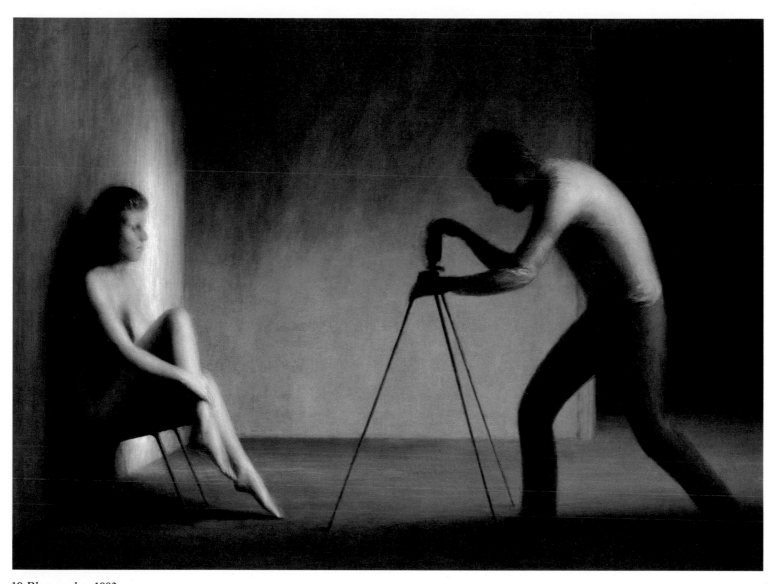

19 *Photographer*. 1983.
Oil on canvas. (Private
collection)

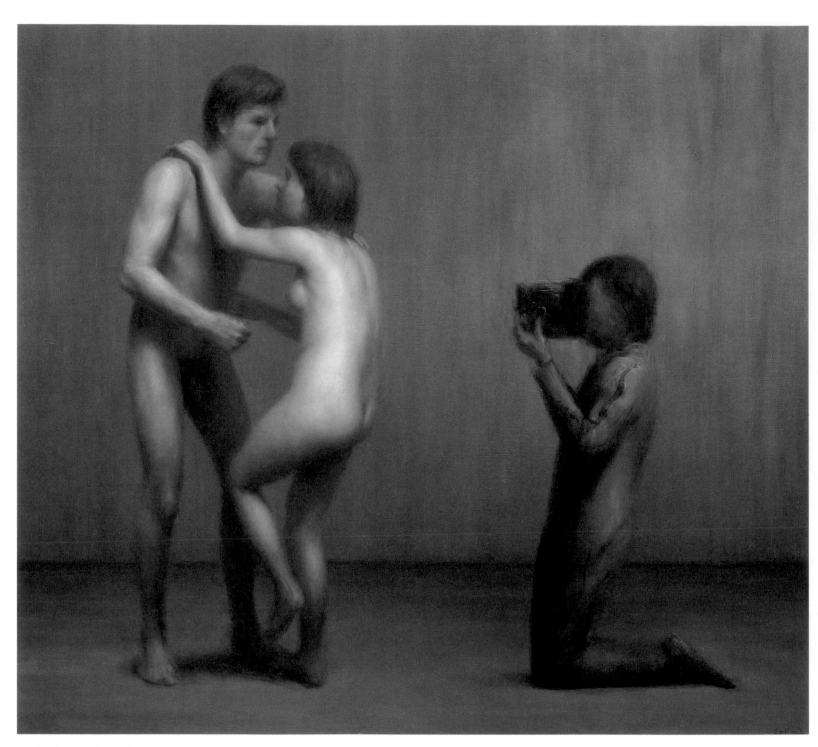

20 *Car Park*. 1984. Oil on canvas. (Private collection)

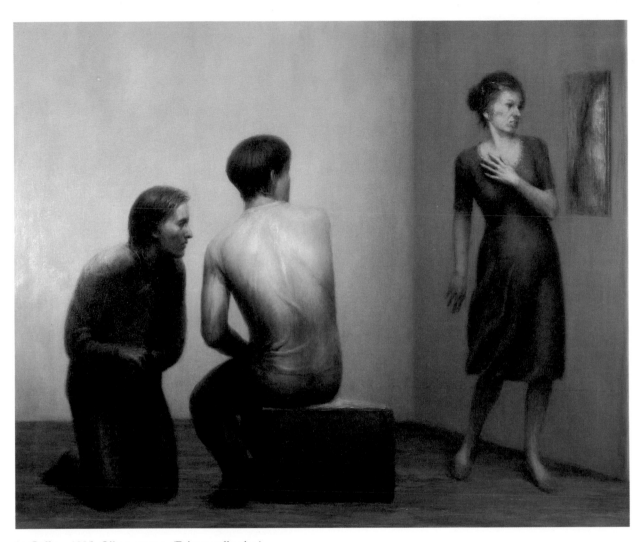

21 *Gallery*. 1985. Oil on canvas. (Private collection)

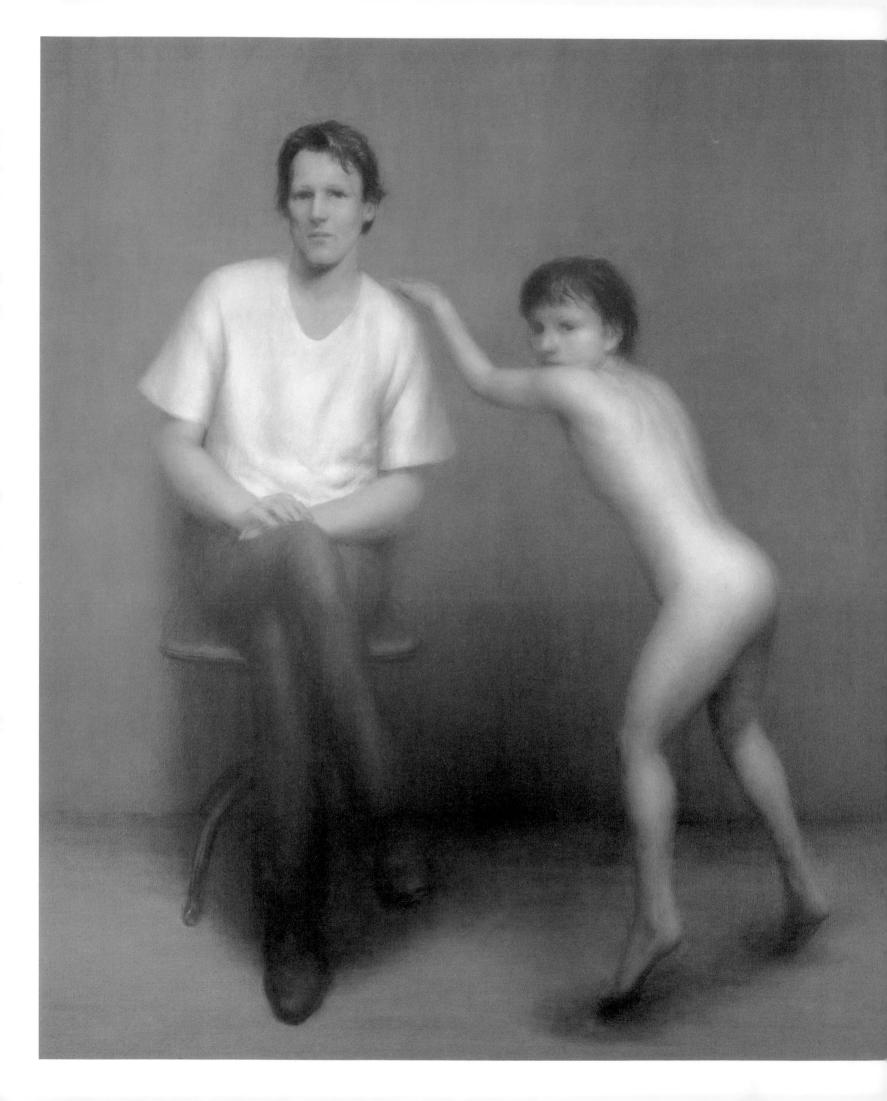

approach, and stares out of the picture. The atmosphere, with its hint of the forbidden, relates the painting to the second version of *Family*, already discussed.

An earlier work, *Diana and Actaeon* (23), is at first glance slightly more conventional in its approach. Closer inspection demonstrates that this is in fact one of Holland's most complex pictures, with much that is puzzling about it. It seems to conflate several different mythological subjects. Rather than being outdoors, in the woods, as one would expect of a Diana, this goddess is shown indoors, on a bed, like Titian's *Venus of Urbino*. Like Titian's *Venus* she gazes levelly at the spectator. There are also close parallels with another famous Titian, the *Danae* in Madrid, where the reclining nude has a female attendant – an old woman who holds up her apron to catch the shower of gold. Here, too, there is an old woman, who raises, not her apron, but the upper sheet. This gesture seems to have two functions – it hides the goddess's more private parts from the onlooker outside the picture space, but at the same time reveals them to a shadowy figure standing behind her. This figure, presumably Actaeon, may either be a picture-within-a-picture, or a reflection in a mirror – in which case Actaeon is placed more or less where the spectator stands (with the further implication that Actaeon and this onlooker are in fact one and the same). To complicate matters still further this standing figure seems to form part of an urban street scene, with a smaller figure visible in the distance under a lamp-post.

As this description makes clear, *Diana and Actaeon* is a compendium of ideas

borrowed from the great masters. There seem to be references to Velasquez's *Las Meninas* (the use of a mirror image) and to Manet's *Olympia* (Diana's self-possession, and the directness of her gaze) as well as to Titian. But the narrative is elided in a way which is not typical of traditional mythological painting, which springs from a unified culture. The cultural fracture is once again stressed by a detail of dress – the old woman who raises the sheet is, like Zeus in the painting of *Ganymede*, wearing recognisably modern clothing.

One notable feature of *Diana and Actaeon* is the way, subtle and caressing, in which the actual flesh is painted. Holland notes that the first Old Master to arouse his passionate interest was Titian. What especially fascinated him about Titian's work was the painting of flesh. He notes that: "A large body of the technique of western painting is related to this – I mean the whole business of sorting out the ground colour so that the colour of flesh is related to it."

Questioned about the voyeuristic element in many of his paintings of nudes, he adds: "Another element which should be added to that is the element of touch. With the nudes, not only do you see flesh, but the paint itself, the way it is put on, gives you the impression that you are actually stroking flesh, feeling it with the fingers." That seeing also incorporates the idea of touching he describes as "the privilege of the artist."

Eventually narrative elements, also mythological ones, start to drop away. The nude becomes important as a subject in itself. Holland points to a major triptych of 1984 (24, 25, 26) as marking an important

22 *Ganymede*. 1983.
Oil on canvas. (Private collection)

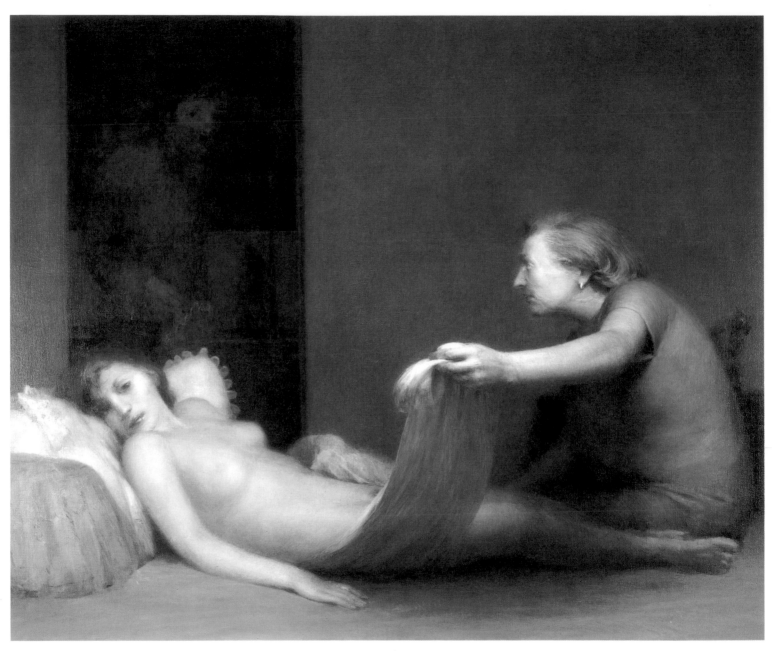

23 *Diana and Actaeon*. 1980. Oil on canvas. (Private collection)

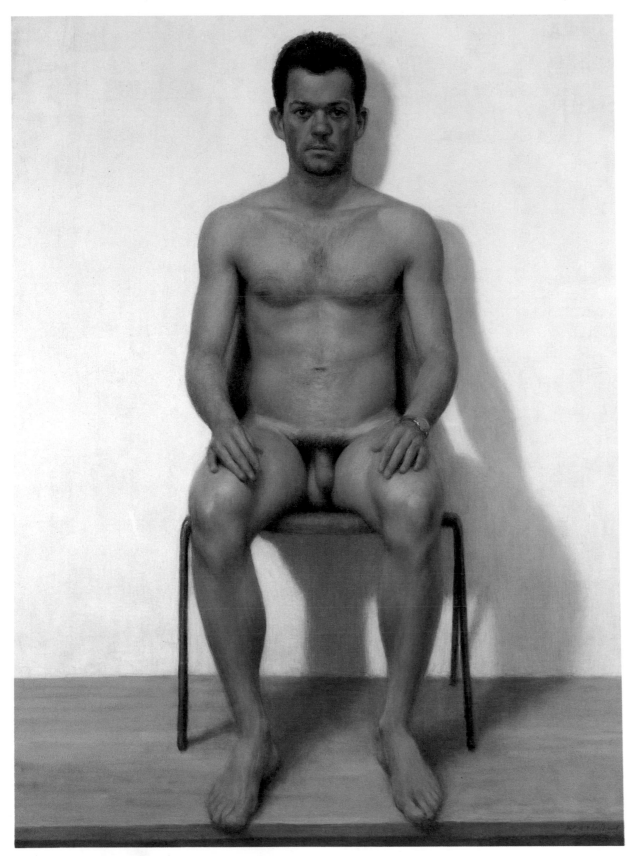

24 *Phil*. 1984. Oil on canvas. (Glyn Vivian Art Gallery)

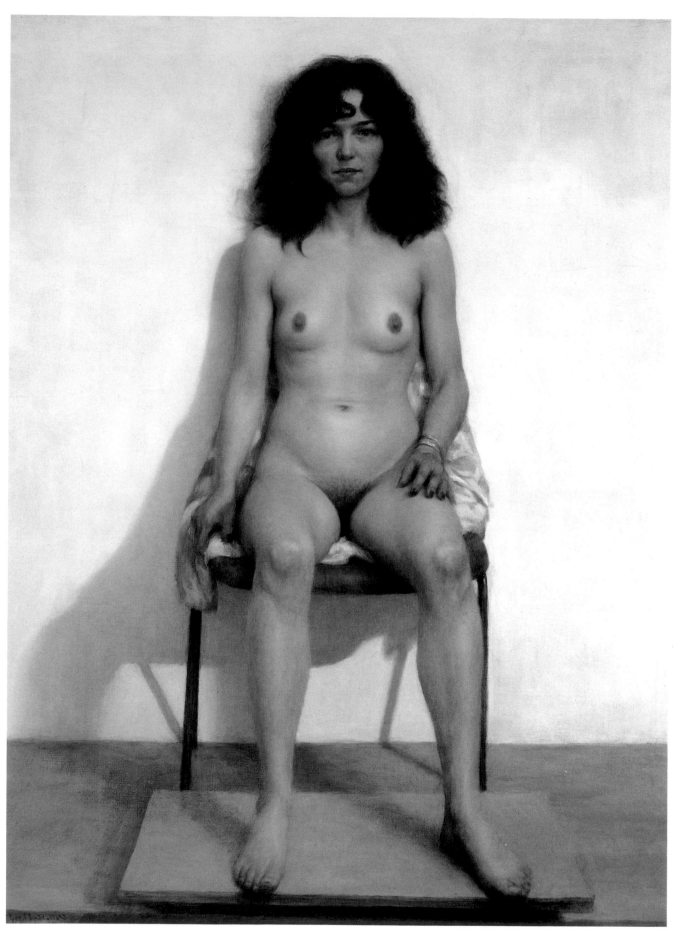

25 *Ess*. 1984. Oil on canvas. (Glyn Vivian Art Gallery)

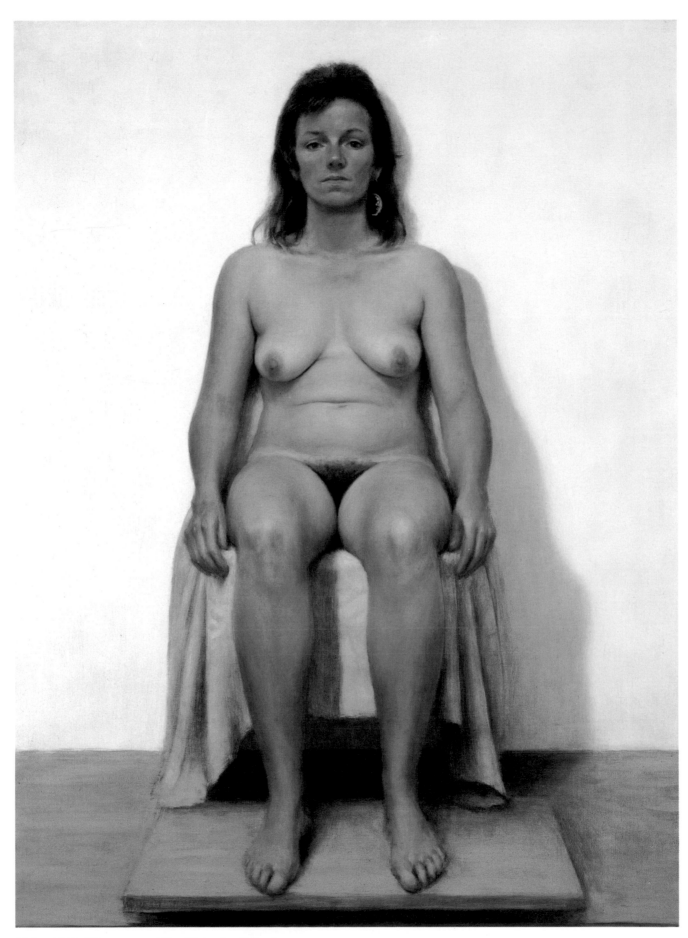

26 *Sue*. 1984. Oil on canvas. (Glyn Vivian Art Gallery)

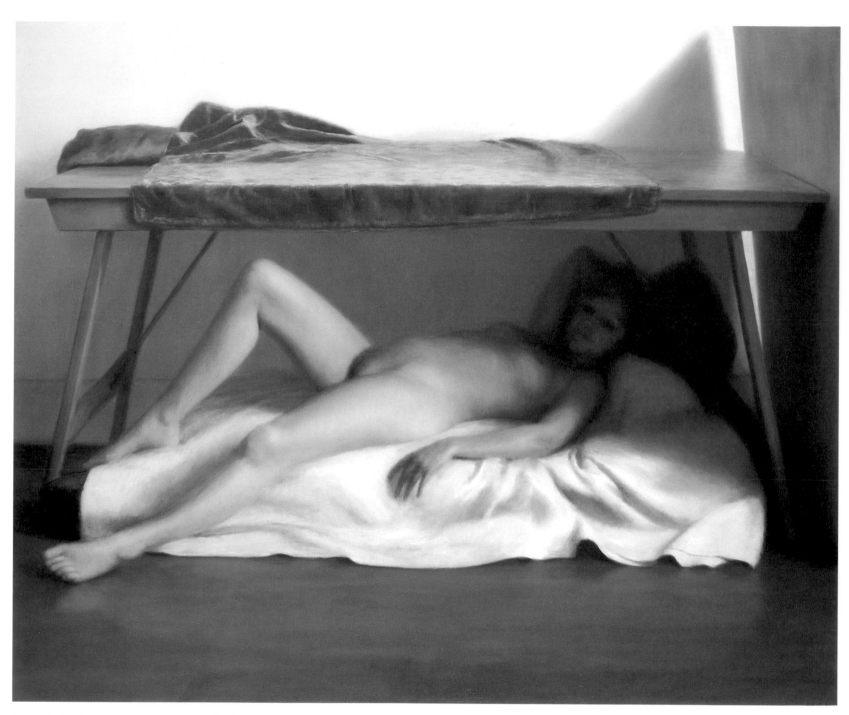

27 *Table*. 1987. Oil on canvas. (Private collection)

turning point in his development. It consists of three seated nudes, two females flanking a male. The figures are portraits in the fullest sense, without a trace of idealisation, and they stare directly out at the spectator, confronting him with the fact of their nudity. The portrait-like nature of the depiction can be verified, if verification is necessary, by looking at some of the more conventional portraits Holland has occasionally produced, in particular the fine self portrait which forms the frontispiece to this book. The artist notes, with some amusement, that these three nudes are the only works of his which have ever been censored, despite the fact that others, closely examined, have a content which is more questionable and disturbing. The triptych had to be withdrawn from an exhibition in Paris, because the imagery was considered too aggressive.

These three paintings nevertheless remain somewhat isolated in terms of Holland's continuing development. This is more easily traced through a series of paintings where the nude is treated in a very different fashion. *Table* (27), from the same year as the triptych, uses a slightly bizarre motif – a figure reclining on a mattress, completely sheltered by the piece of furniture which gives the painting its title. Next comes a work (28) in which the nude and her bed are actually *on* the table, the figure now partially concealed by a pink drape. Related to this, but in fact slightly earlier, is a smaller work which shows the same blue (bottom) and pink (top) sheet, but only part of the nude herself (29). This cropped image can be related to another nude of the same period, where the figure is partially concealed by a large cardboard box (29) – the image of the box was to have a long future in Holland's work.

Closely related to these paintings, but less drastic in their treatment of the motif, is a series of images where the female nude is seen in relationship to a mirror, though she does not evince the same sort of horror at seeing her own reflection as the fully clothed female figure in *Gallery*. In *Mirror* (30), the nude quietly contemplates her own image, apparently unaware of the fact that the artist is looking over her shoulder. This is one of the paintings in which Holland comes closest to Degas – an artist whom he reveres. There is also a hint that he is perhaps thinking of the *Rokeby Venus* of Velasquez, where the nude also contemplates her face, but not her figure, in a mirror of about the same size. The scene is repeated in another, slightly larger painting (31), where the figure is seen from the side and the composition is therefore less intimate. A similar motif can be found in Picasso paintings of the Rose Period.

The device of a reflecting surface is used in a slightly different way in another painting of the nude (32), which is in fact slightly earlier, though it looks more developed than the two which have just been discussed. Here the model clearly cannot see herself in the mirror beside her. She reclines passively beside it, indifferent to its presence. The composition shows her torso as if it were an inanimate object. One might say that the nude, here, is treated as a branch of still life.

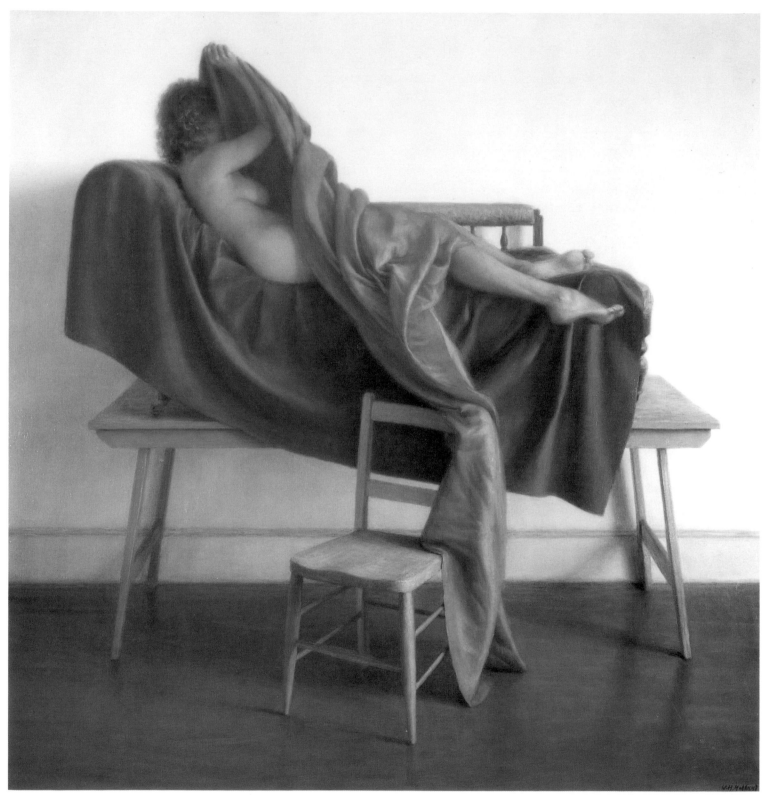

28 *Flier*. 1986. Oil on
canvas. (Private
collection)

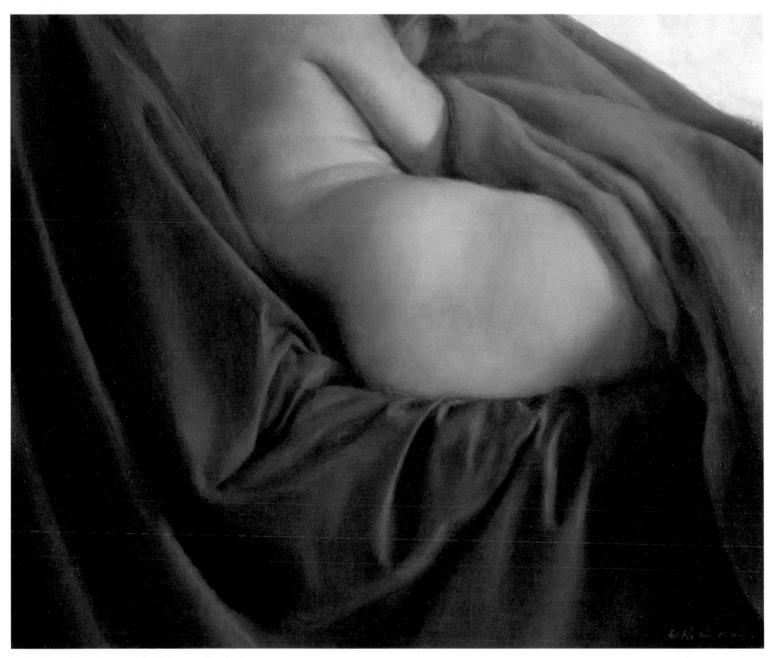

29 *Cloth*. 1987. Oil on panel. (Private collection)

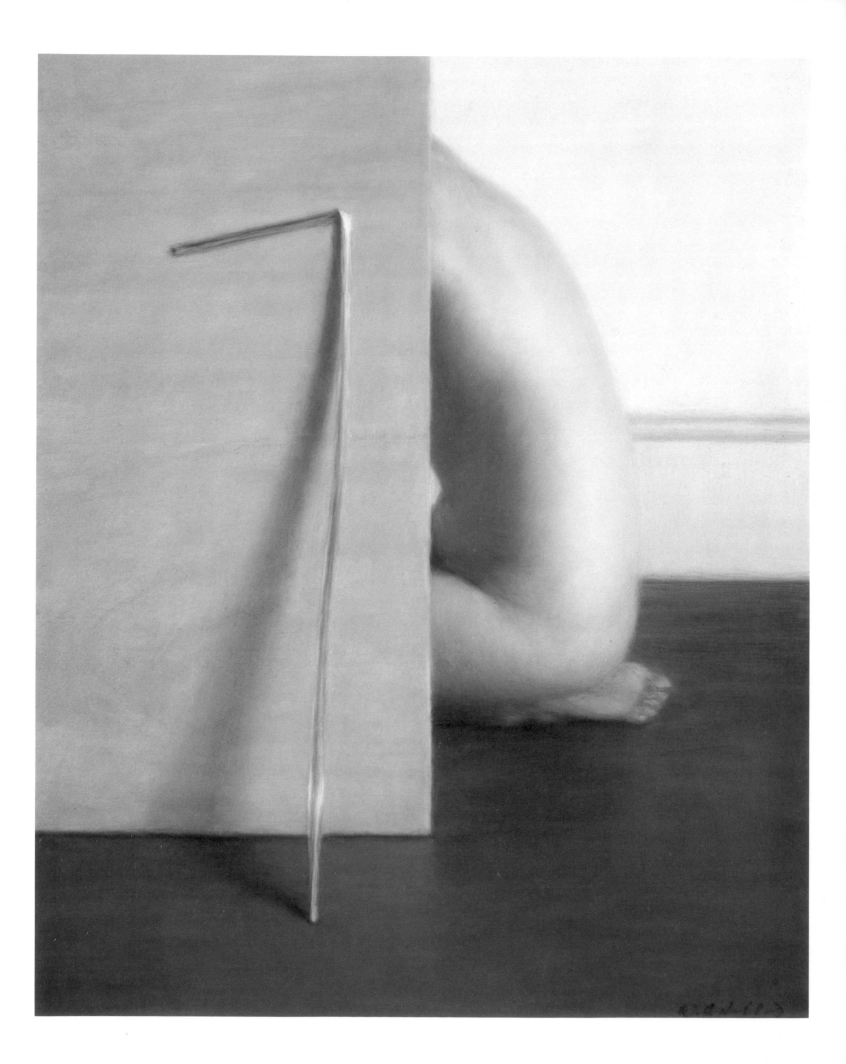

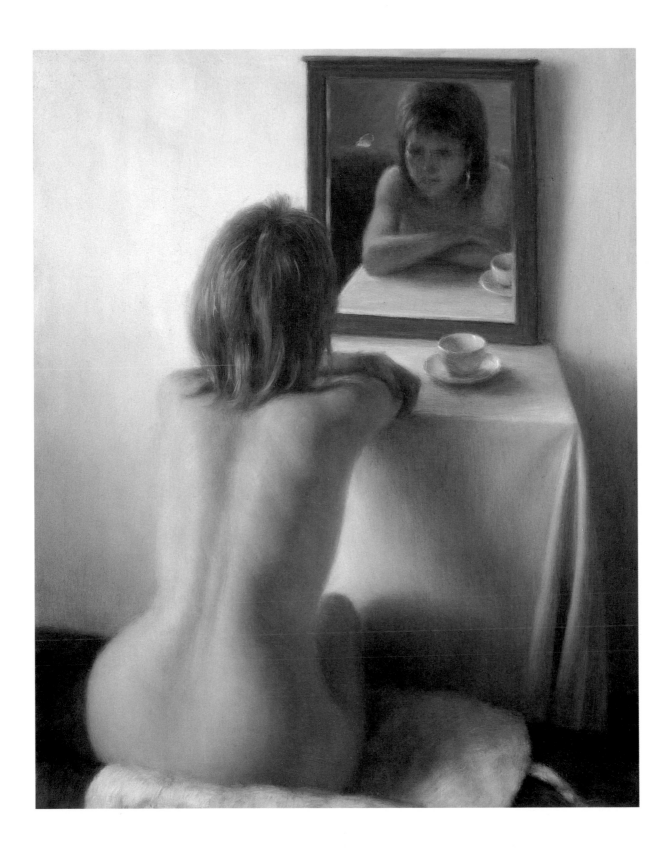

29a *Still Nude*. 1987.
Oil on panel. (Private
collection)

30 *Mirror*. 1987. Oil on
panel. (Private
collection)

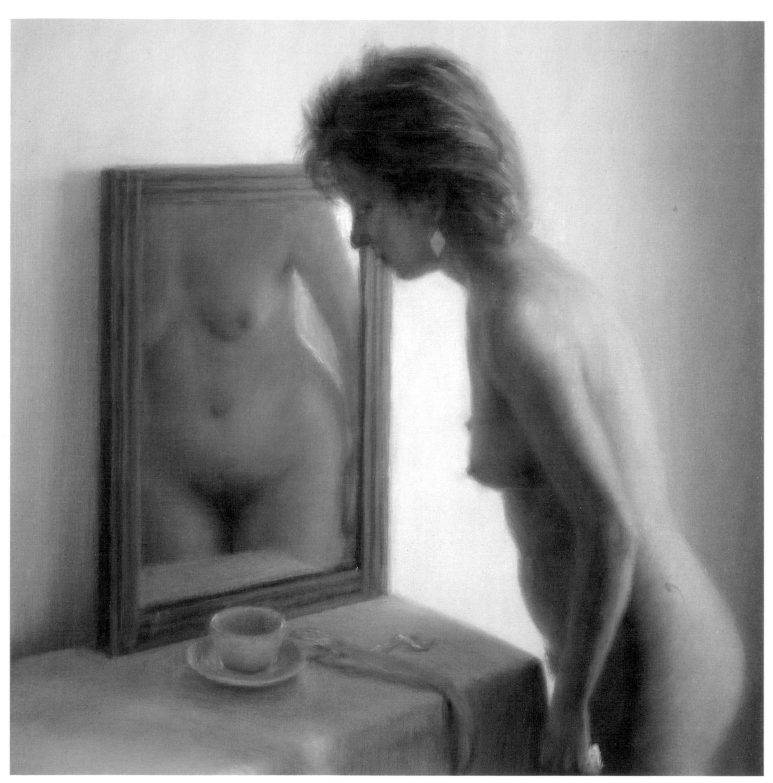

31 *Ribbon*. 1987. Oil on panel. (Private collection)

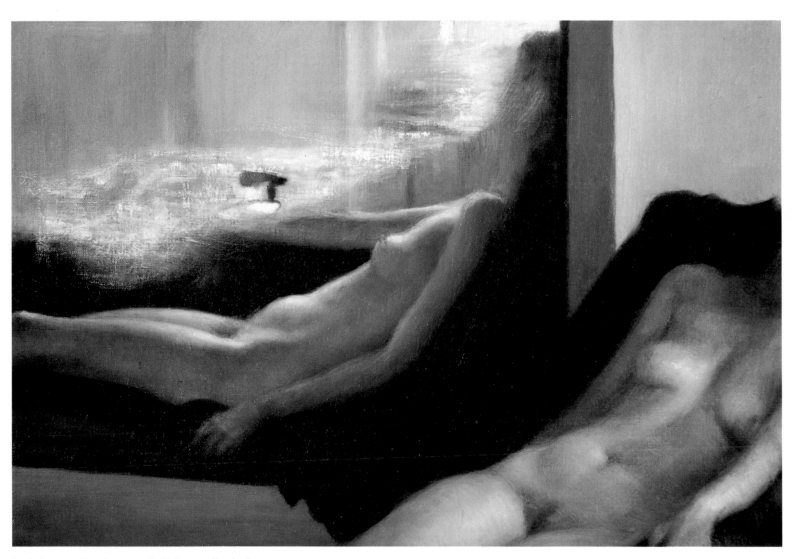

32 *Mirror*. 1986. Oil on panel. (Private collection)

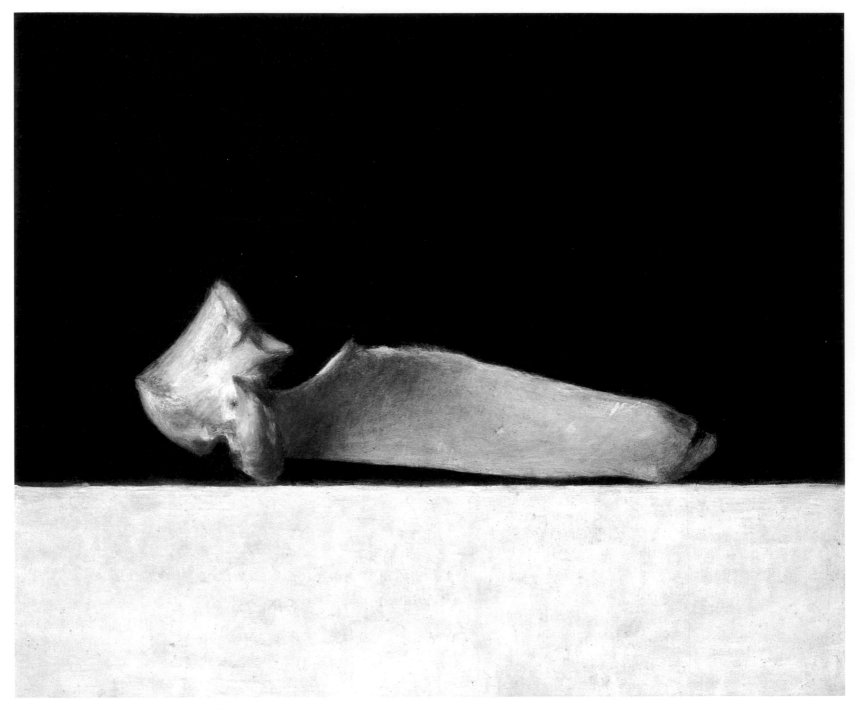

33 *Bone*. 1982. Oil on panel. (Collection of the artist)

3

Still life occupies a curious place in the history of European painting. The first independent still life compositions make their appearance in Ancient Roman art. Amongst the wall paintings found at Herculaneum, for example, is a composition with objects placed on two levels – shells, a vase, a lobster and a live bird. The function of paintings of this sort seems to have been purely decorative.

After this the genre disappeared for many centuries, to manifest itself again only in the late Middle Ages. When it surfaces once more, it seems to be typical of the art of northern rather than southern Europe. One source may be the border decorations for prayer books, which began to be painted with *trompe l'oeil* representations of jewels and flowers. In fact, two distinct tendencies are visible, though these are not generally opposed to one another. In the first place, the painter wants to show off virtuoso skills, in particular by deceiving the eye, so that the spectator confuses what is in fact only a painted surface with reality itself. In the second place, he wants to present objects in an emblematic way, so as to teach a moral lesson. Both of these impulses continued to play a part in the fully developed still life painting of the 17th century – the genre became immensely popular in Holland, and it was also widely practiced in

Spain, where, in fact, it is a sign of persistent northern influence in Spanish art.

By this time, however, European art had a fully developed system of genres – that is a hierarchy of different types of art, with history painting and religious painting at the top, followed by portraiture, landscape, and finally by still life at the bottom. That is, as the painter became increasingly recognised as the equal of practitioners of the "learned" and quasi-gentlemanly professions – the law, medicine, authorship for example – the still life painter continued to be regarded as an artisan. In the 17th century no professional still life painter could ever have won a knighthood, as Rubens and Van Dyck did. This built in disability continued to affect painters even in the next century – Chardin, for example, deeply resented the lowly status which his chosen subject-matter imposed upon him.

If this situation showed any signs of change, it was not until the appearance, first of Cezanne, then of the Cubists. Cezanne seems to have adopted still life for purely practical reasons. Inanimate models gave him fewer problems than live ones. When he painted flowers, he even finished up using paper blossoms rather than real ones. The Cubists, who owed so much to Cezanne – though they also arguably mis-

interpreted him, just as Cezanne misinterpreted Poussin – turned to still life arrangements for similar, but not quite identical motives. Here the need was not so much for an unchanging, wholly motionless motif, but for a motif whose appearance would not be hopelessly confused by the painstaking process of visual analysis. That is, it was easier to recognise a guitar or a wine-bottle in an Analytic Cubist painting than a human figure – much less a composition containing several human figures.

Analytic Cubism was probably the moment of highest prestige for still life. Later, it became involved in the collapse of the whole traditional hierarchy of genres brought about by modernism.

Still life painting of a more traditional sort made a tentative appearance in Holland's work at the beginning of the 1980s. One of the earliest paintings of this sort is a study of a single bone (33), which dates from 1982. The bone is placed on a white, box-like base, so that it looks like a piece of modernist sculpture – one recalls that bones like this were a source of inspiration for Henry Moore. This painting was followed, the same year, by a more elaborate version of the same subject (34), showing three bones. These are placed in a kind of architectural setting. The picture is not large but the setting suggests that the objects themselves are substantial – perhaps as tall as a man in the case of the largest. This is an isolated example of the disorientating, quasi-surrealist effects which make more frequent appearances in Holland's work several years later, by which time still life formed a much larger proportion of his production.

The still life paintings Holland made in the early 1980s are for the most part deliberately modest and matter-of-fact. There is, for instance, a series depicting old-fashioned box cameras. Sometimes the camera is seen in isolation (35, 36), and sometimes with another object – once, for instance, with a china vase in the form of a hand (37). There are also paintings which feature objects which have almost lost their identity – bits of rubbish picked up in the street. In one painting (38) the objects depicted are the discarded wing-mirror from a car, a section of metal tubing and a piece of wadded up cloth. In another, there is a large piece of twisted silver foil (39). The interesting thing about the paintings in this group is the way in which they manage to avoid all the traditional symbolic resonances connected with the art of still life.

At the moment when Holland painted these he seems to have been a little unsure about what direction to take. There are also other still lifes of a more conventional kind – one with a skull (40), which recalls the Vanitas theme prominent in much 17th century still life painting. Another, with a pottery bowl and a piece of cloth on a scrubbed wooden table-top (41), carries an echo of Chardin and Fantin-Latour. A third, featuring a wooden hand wrenched from a mannequin plus a piece of paper ribbon (42) recalls the preoccupations of Italian *pittura metafisica*. Even more strongly reminiscent of this early modernist art movement are two striking paintings which depict milliner's moulds (43, 44). One of these moulds reappears in a more elaborate composition where it is combined with a blue tassel (45).

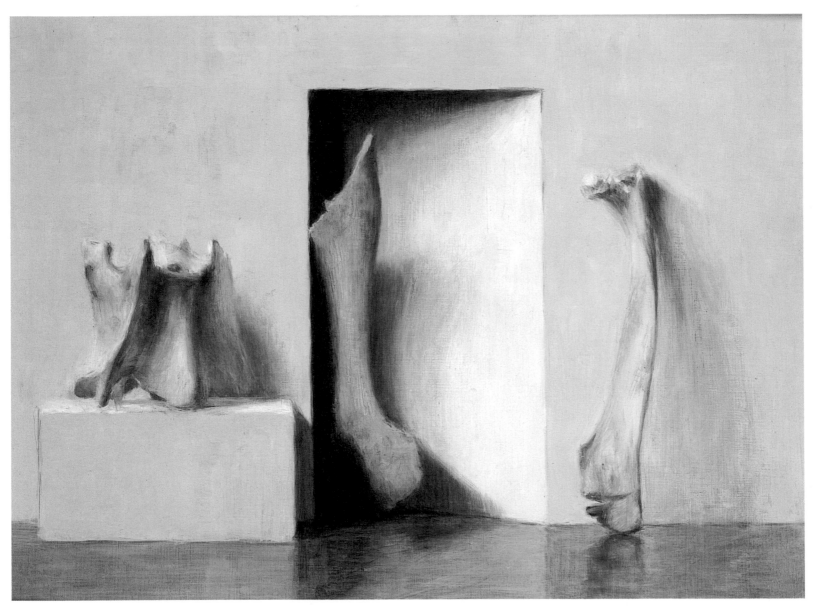

34 *Study*. 1982. Oil on panel. (Private collection)

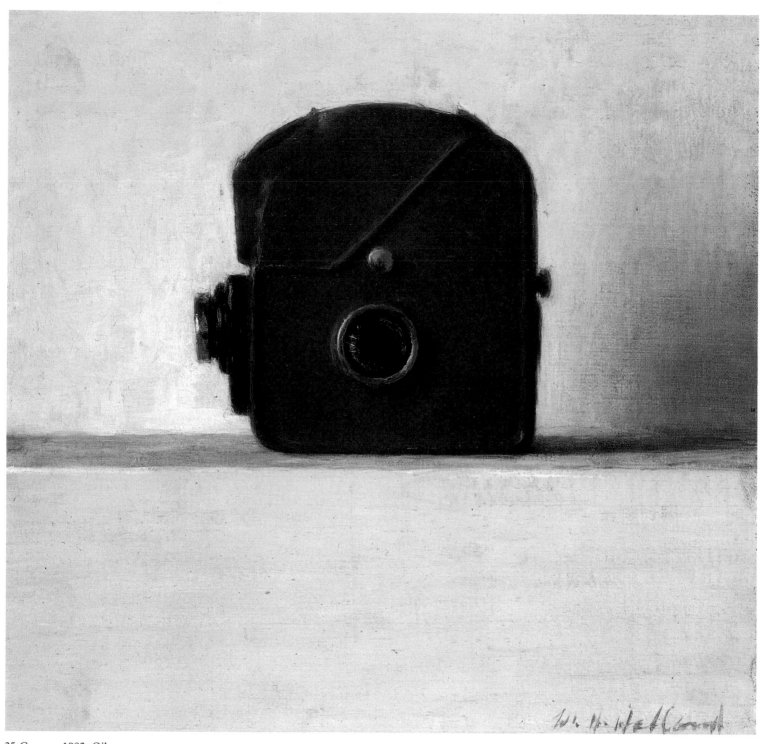

35 *Camera*. 1982. Oil
on panel. (Private
collection)

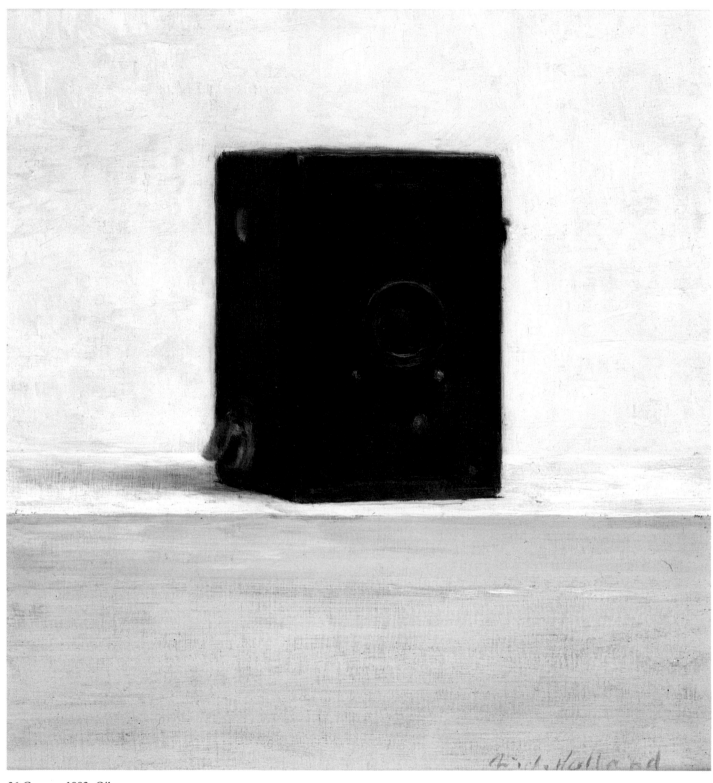

36 *Camera*. 1982. Oil
on panel. (Private
collection)

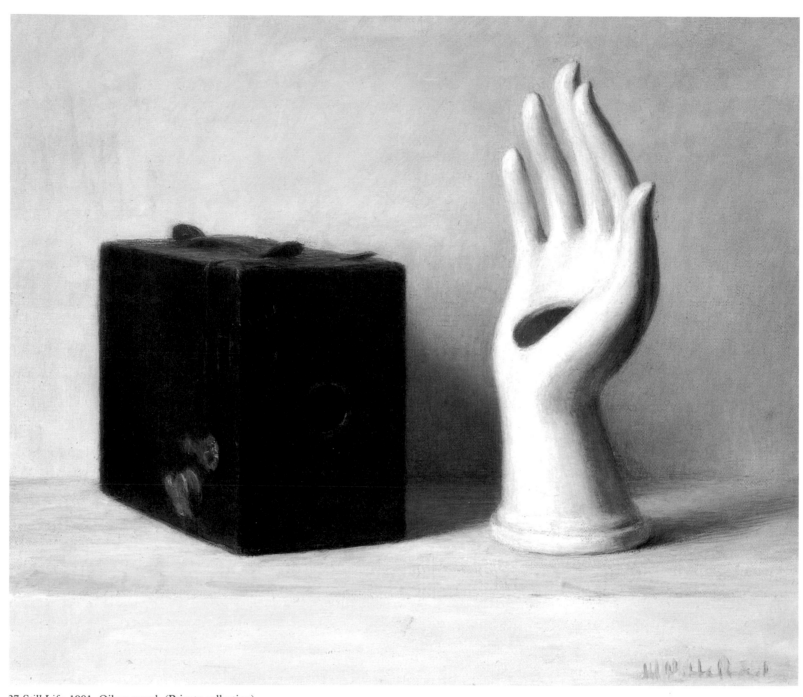

37 *Still Life*. 1981. Oil on panel. (Private collection)

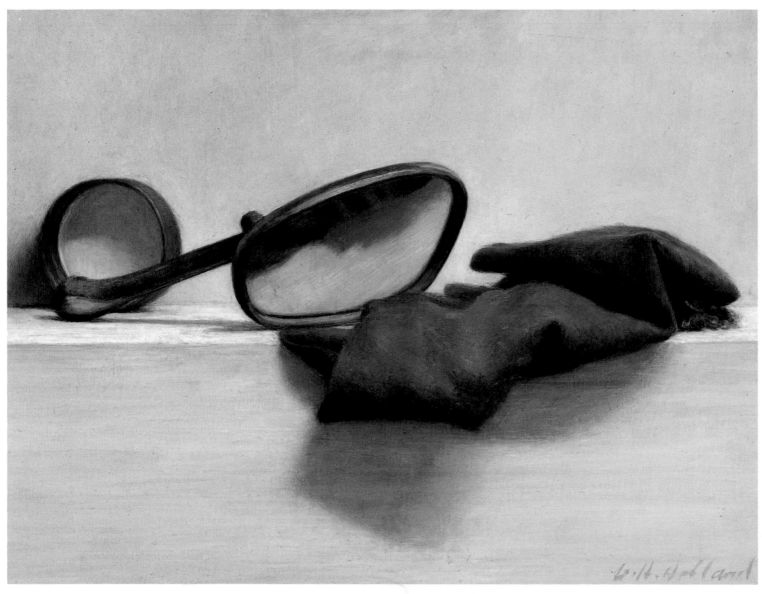

38 *Still Life*. 1981. Oil on panel. (Private collection)

39 *Foil*. 1982. Oil on panel. (Private collection)

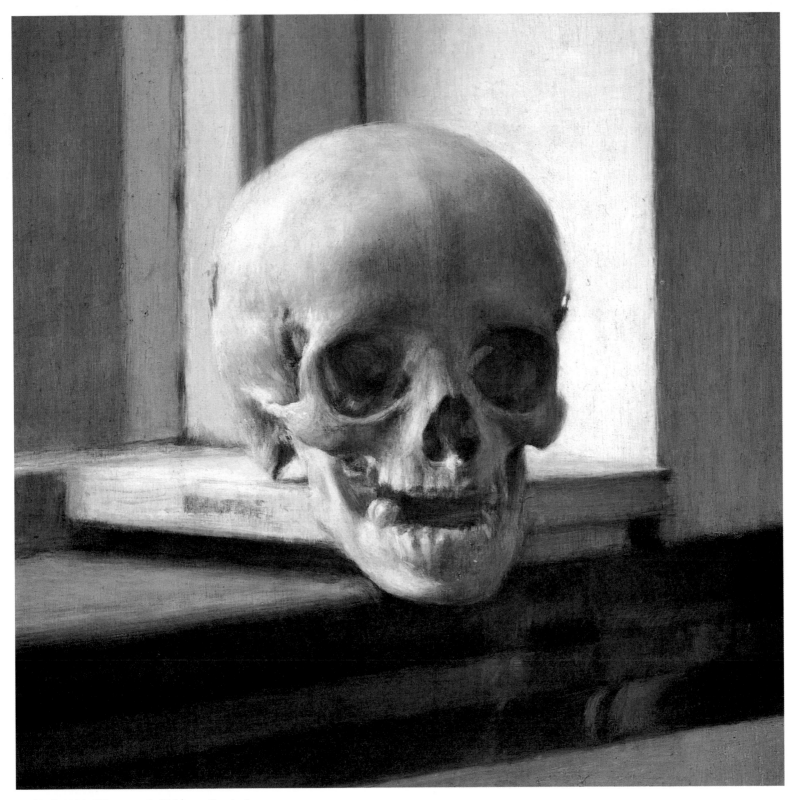

40 *Skull*. 1984. Oil on panel. (Private collection)

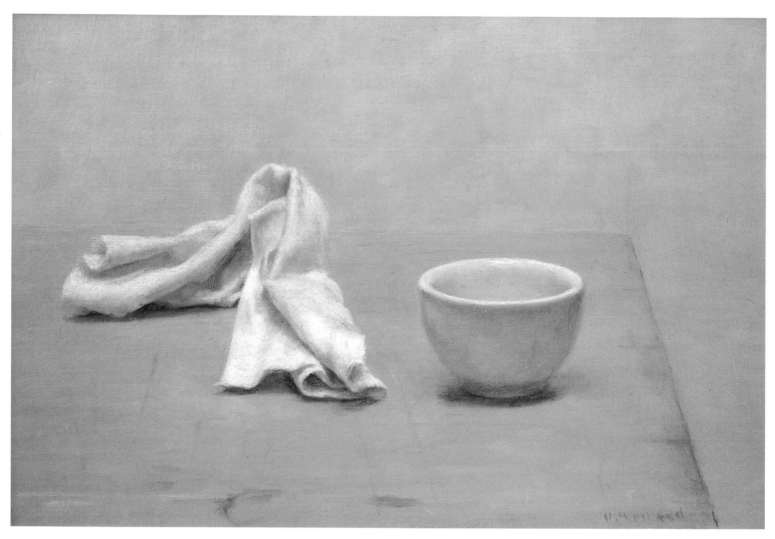

41 *Cup and Cloth*. 1986. Oil on panel. (Private collection)

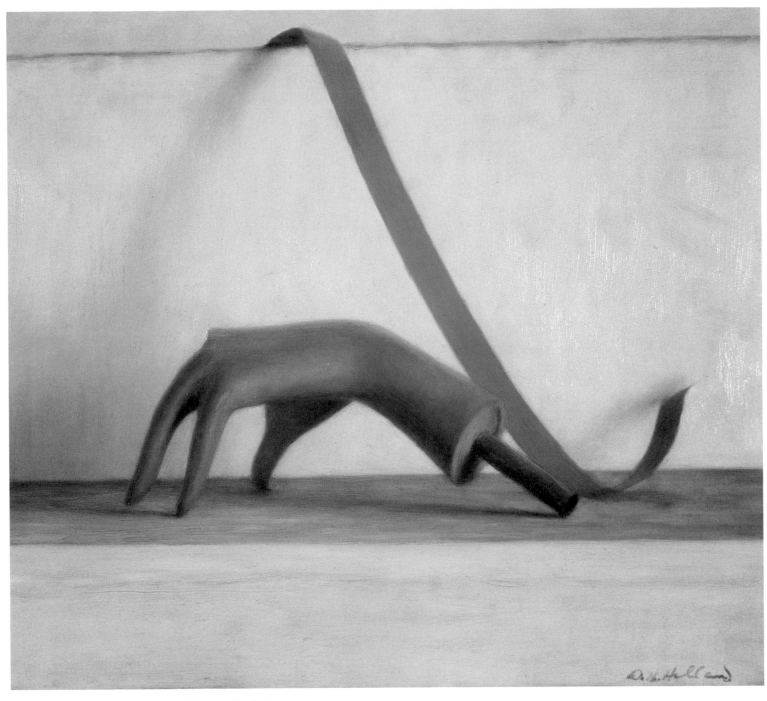

42 *Mannequin*. 1986. Oil on panel. (Private collection)

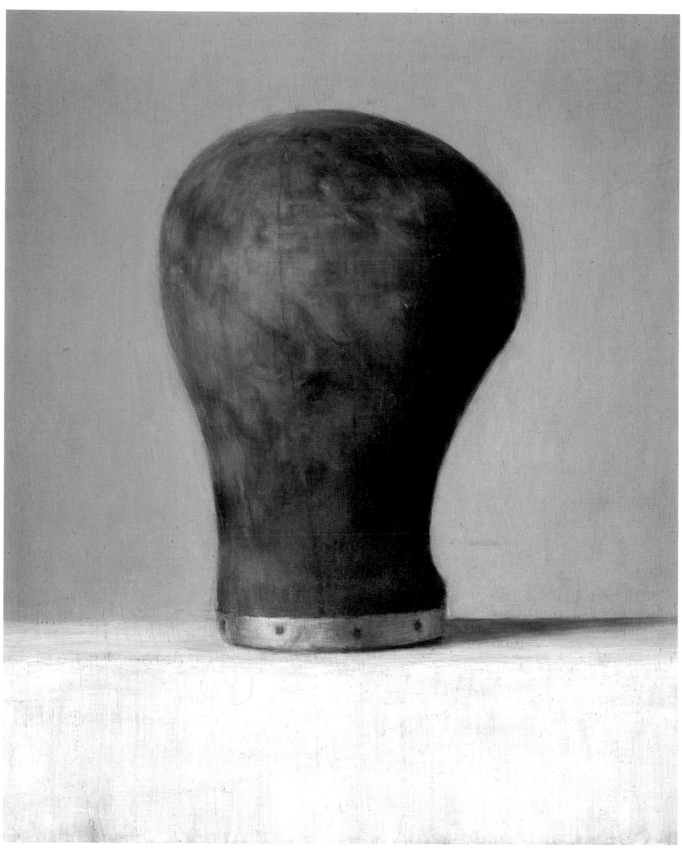

43 *Milliner's Model*. 1984. Oil on panel. (Private collection)

It is rather easy for the critic to read into these paintings messages which the artist did not in fact intend. Holland says: "I often find that the paintings which lead on to something else are the ones that you do in an almost throwaway manner, for purely technical reasons. You are in fact freer because you don't have an emotional involvement with them." He notes that many of the objects in these early still lifes were chance finds. This was the case with the section of ornamental cast-iron railing featured in a painting of 1986 (46). More surprisingly, one of the milliner's models was something which waylaid him. "It was bang in the middle of the road – there, waiting for me." There is a footnote to be added to this, however. Cardiff, the city where Holland lives, is even more than most others in Britain a community in transition, moving from one phase of industrialism to another. His studio is now in an area near the docks which is in the process of being redeveloped. The rubbish he finds in the streets is therefore redolent of social and economic change, and the objects which appear in the still lifes of this phase are often as effortlessly evocative of a certain way of life as the kitchen utensils favoured by Chardin.

If one examines the still life paintings of the early and mid-1980s as a complete group, one can in fact see several different approaches being explored. Some paintings are deliberately minimal. This is the case, for instance, with a painting showing a brick, with a piece of transparent plastic folded around part of it (47). Scarcely more elaborate is the painting in which the wing-mirror already mentioned reappears, now accompanied by a piece of corrugated cardboard (48). The main impulse at work

here seems to be what Holland describes as his "love of copying". The pictures are the product of his tendency to fall in love with what he sees. At the same time, the very accuracy of the representation has something alienating about it. Yet perhaps this, too, is part of the point: "I suddenly realised that it wasn't up to me what the painting said. That people brought their own emotions, their own experiences, their own attitudes, their own worlds to the painting. That if I wanted to say something it would have to be on an emotional level."

At the same time, there are a number of Holland's still lifes which are less drastic in their approach, and which are often slightly later in date than the ones I have just cited. One called *Box* (49) and another called *Ribbon* (50) date from 1987, and offer set ups of a more elaborate, and therefore perhaps more expected kind. In the first a large cardboard carton – seen also in some of the paintings of nudes – serves as a pedestal for a china vase. The vase's lightly humanoid, bust-like form, with its touch of popular surrealism, makes it typical of one aspect of 1950s design. That is, the object is out of date but not yet antique. Under the vase is a piece of green cloth, and behind it a dark blue curtain. A trailing paper streamer, fixed to the wall, tumbles over the box itself and finally falls to the floor in the foreground. *Ribbon* features a similar streamer, a smaller cardboard box and a piece of bent metal. The green cloth now covers the table and on the wall hangs a china mask.

These two paintings are paraphrases of a familiar type of baroque still life full of tumbling dishes and opulent piles of fruit. The essential rhythms are pared to a

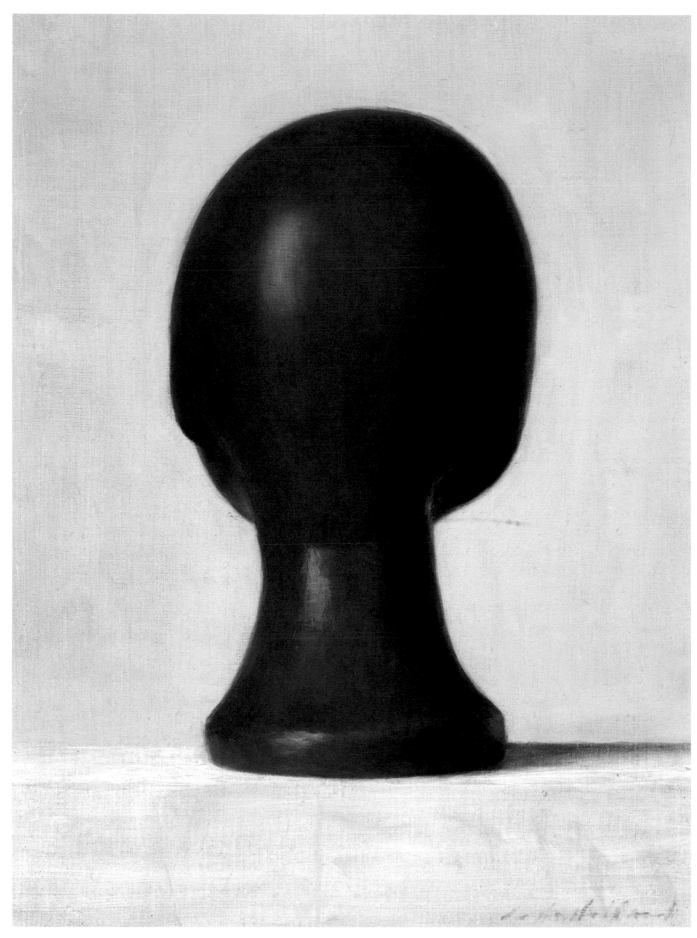

44 *Milliner's Model*. 1984. Oil on panel. (Collection of the artist)

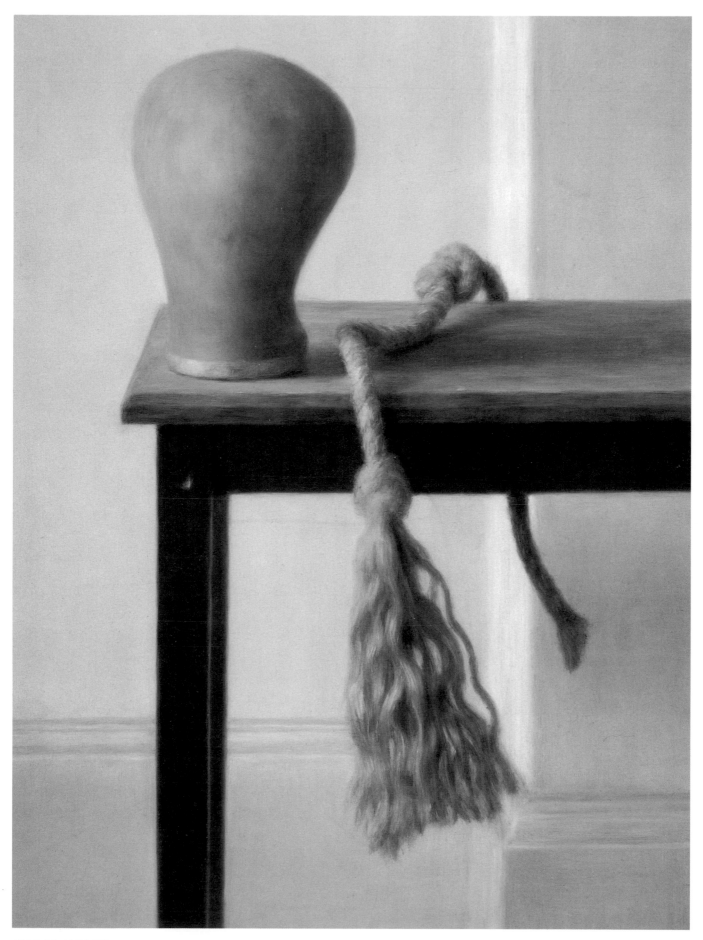

45 *Model*. 1987. Oil on
panel. (Private
collection)

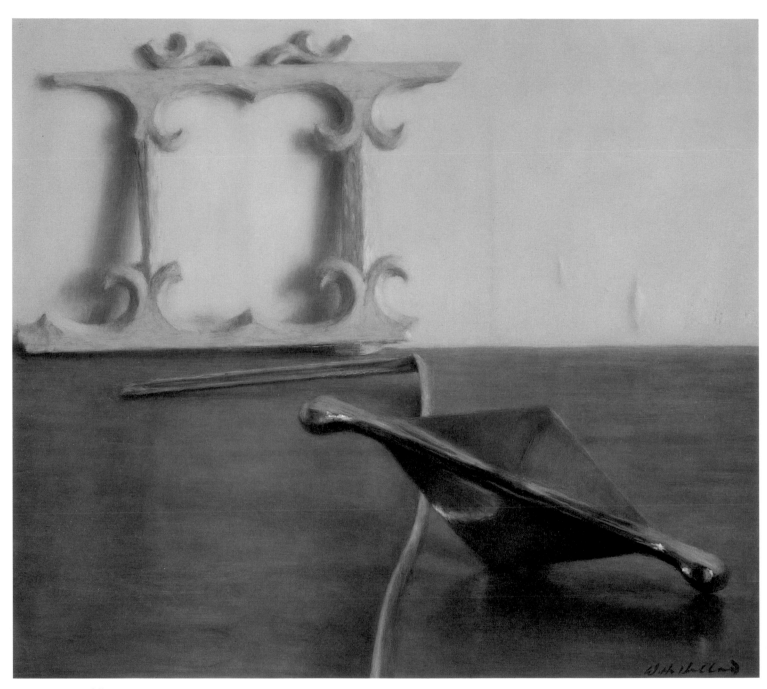

46 *Fence*. 1986. Oil on
panel. (Collection of
the artist)

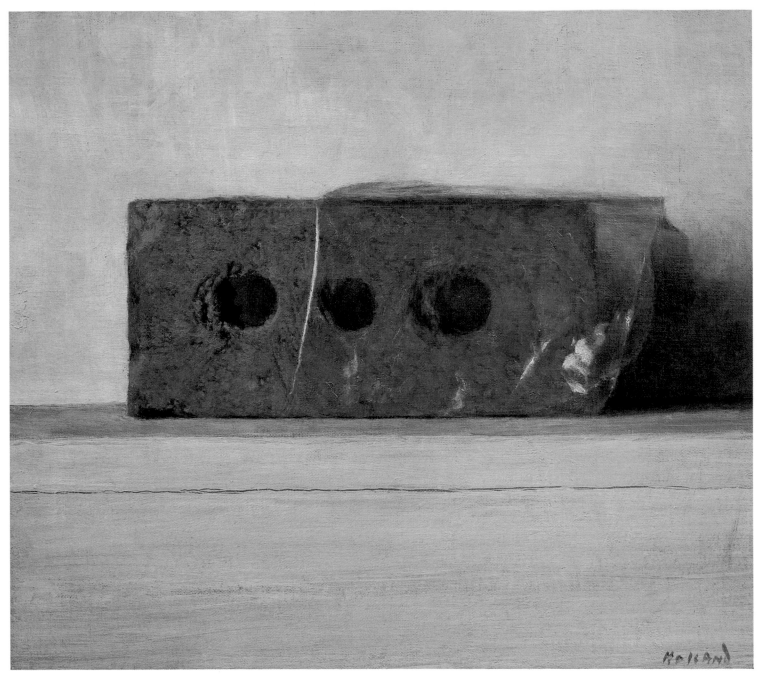

47 *Brick*. 1986. Oil on
panel. (Private
collection)

minimum, then expressed through untraditional, deliberately contemporary materials and objects. There is still, however, a sense that a still life consists not merely of the forms themselves (as in the previous group) but of dynamic relationships of form.

Holland himself might not select any of the paintings just described as being absolutely crucial to his development. Instead, his choice would fall on a small work entitled *Study* (51), painted in 1986. The title exactly describes its purpose. It shows a group of figures roughly constructed from cardboard. The artist prepared these as a way of studying the lighting effects for a planned composition, using a method which would have been familiar to Poussin, who often used small mannequins to fix the positions of his figures and to show how they would be lit. Holland says that what impressed him about this little painting was the ease with which everything came together. "It went like a dream, like a breath in and out." The experience convinced him that a major part of his effort should now go towards representing inanimate subject-matter.

In fact *Study* is not completely isolated in Holland's oeuvre. A tiny painting of 1982 (52), featuring a bone and a plastic doll, can be read as a kind of unconscious preparation for it, and a later work called *Priest* (53) is a direct successor. As the title suggests, this shows, or seems to show, a kneeling figure, busy with something hidden in a cloth-covered shrine. The figurative references, however, are less specific than they are in *Study*. Other paintings done at the same epoch, and using much the same range of materials and props, are more nearly "abstract", in the sense that

figuration, though present, is also in the same way denied. Examples are *Curtain* (54), which seems to show a discarded car seat, or something of that nature, perched on a cardboard box and covered with a cloth – a more mysterious counterpart to the equally arbitrary painting of a nude on a table. Also *Stall* (55), in which the elements are a wooden framework, a red cloth, a piece of cardboard, a blue ribbon and a silvery one.

In this painting the ribbons play an intriguing role. The blue one lies right on the picture-plane; the silver one floats unsupported in a narrow area of space behind the framework but in front of the curtain. This is one of comparatively few paintings by Holland which seem to show the influence of Cubism. The spatial arrangement is directly descended from Analytic Cubist works like Picasso's celebrated *Three Musicians*. The movement in the Picasso is from what is real towards abstraction; Holland's painting goes in the opposite direction – it is a simulacrum of an abstract composition made from undoubtedly "real" elements. There is also a more recent parallel in the so-called Abstract Illusionist style practiced in America by contemporary painters such as James Havard. In Havard's paintings abstract bands and colour patches float clear of one another in a shallow illusionist space behind the picture-plane – it is as if the indefinite forms typical of Abstract Expressionist painting had become real, concrete objects. Somewhat similar spatial effects can also be found in Holland's *Shadow* (56), but here the treatment of space is deliberately ambiguous.

In terms of the artist's development *Shadow* is a particularly interesting work,

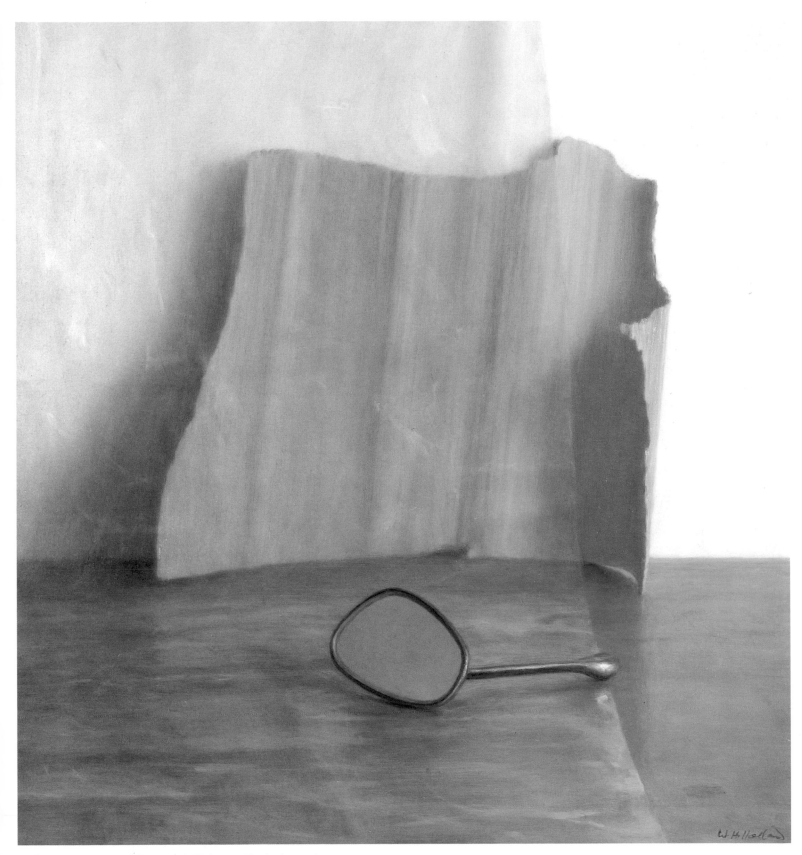

48 *Wing Mirror*. 1986. Oil on panel. (Private collection)

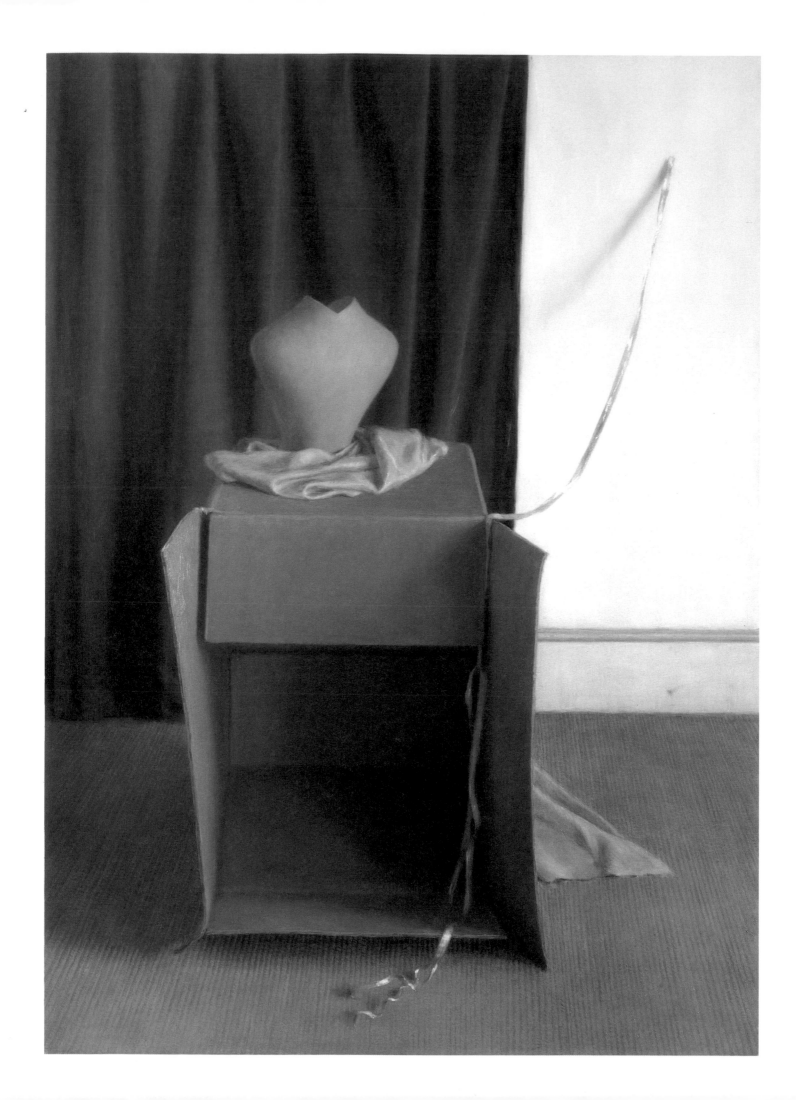

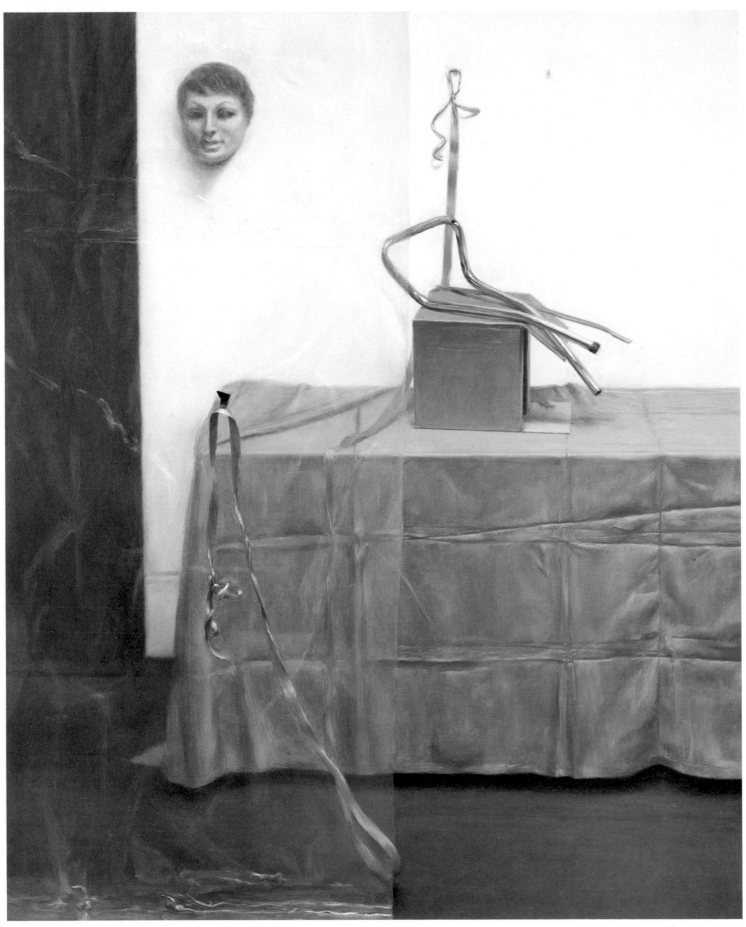

49 *Box*. 1987. Oil on
canvas. (Private
collection)

50 *Ribbon*. 1987. Oil
on canvas. (National
Museum of Wales)

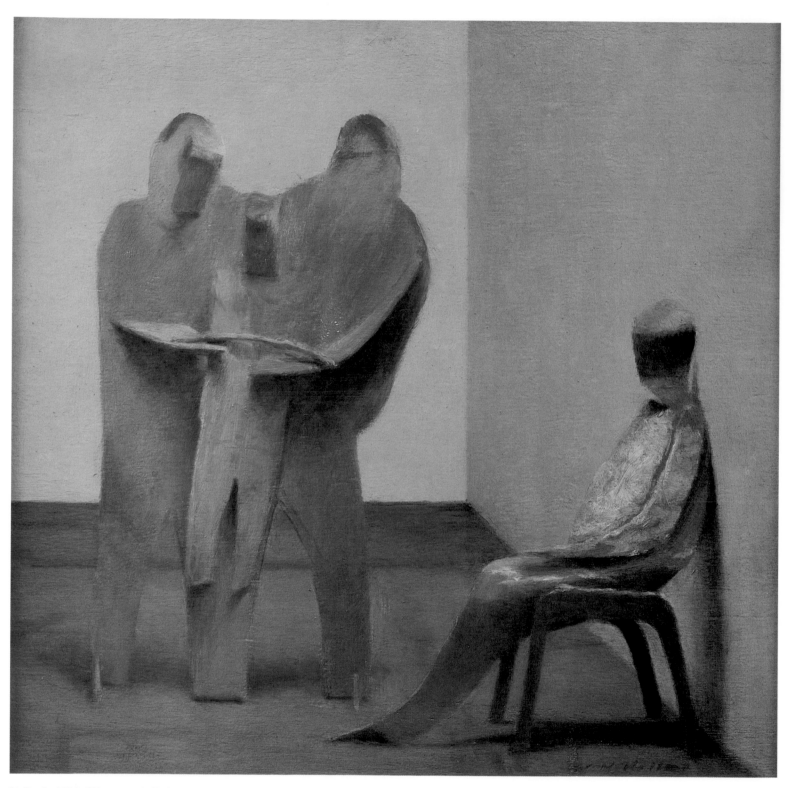

51 *Study*. 1986. Oil on panel. (Private collection)

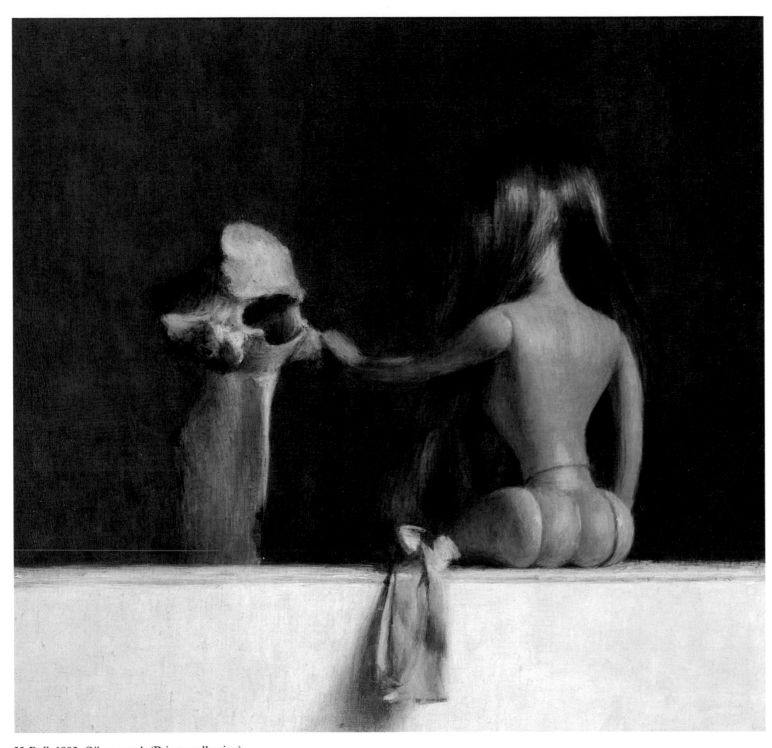

52 *Doll*. 1982. Oil on panel. (Private collection)

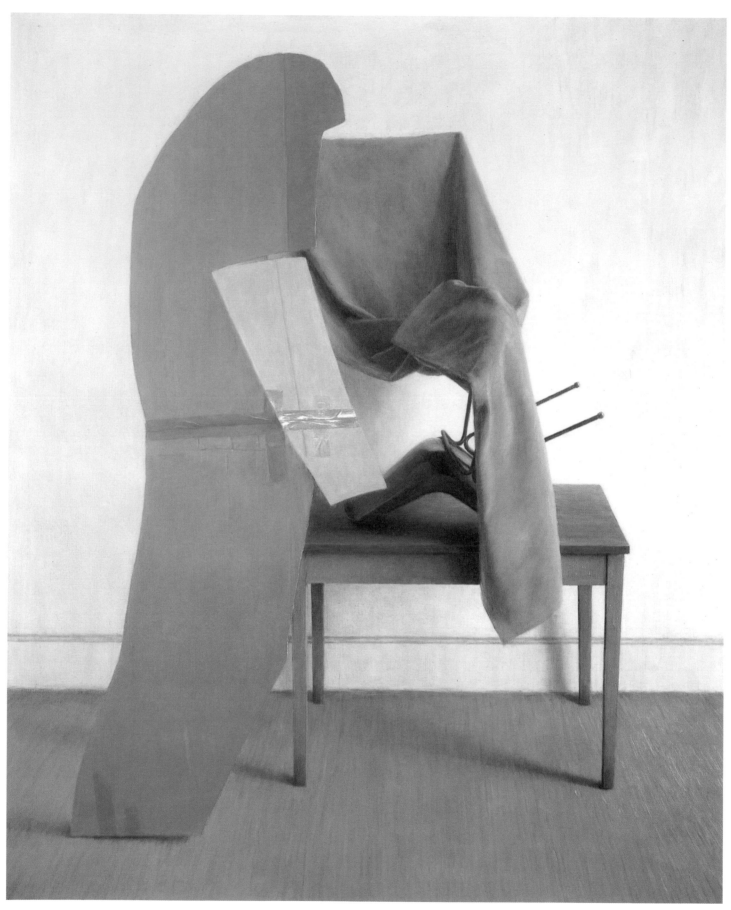

53 *Priest*. 1988. Oil on canvas. (Collection of the artist)

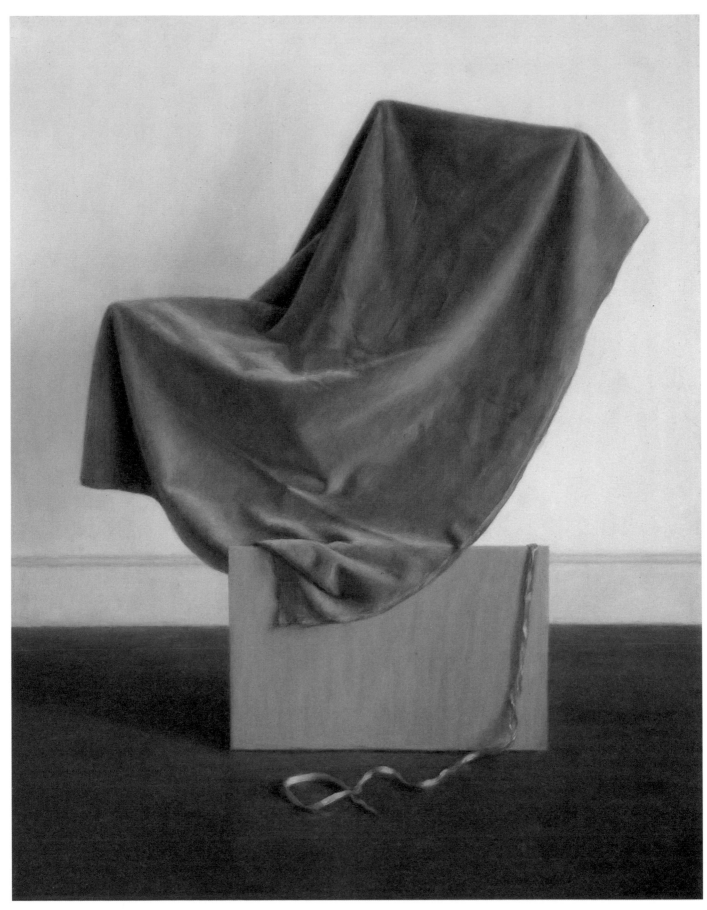

54 *Curtain*. 1987. Oil on panel. (Private collection)

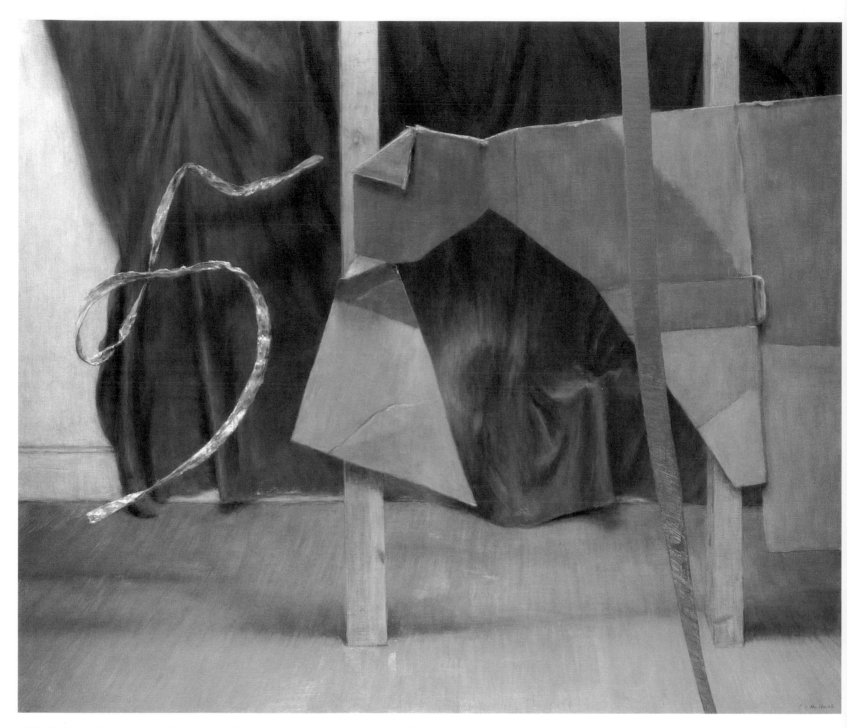

55 *Stall*. 1988. Oil on canvas. (Collection of the artist)

as it summons up Surrealist connotations even more powerfully than it does Cubist ones. There is a very familiar type of painting by René Magritte, in which a representation within the representation – a landscape on an easel in front of a window for example – screens what the spectator is given to understand is its counterpart in reality. Magritte arranges matters so that the edges of the representation on this "screen" precisely coincide with what is visible through the unobstructed part of the window, thus achieving a peculiarly disturbing effect through the confusion of several different levels of reality.

In Holland's *Shadow* what is actually depicted is simpler, the visual paradoxes are less obvious, but the scheme itself is more complex. The composition consists of several elements: first, a support, probably cardboard, cut to form an irregular outline at the top. Then a second, apparently somewhat thicker, piece of cardboard, with a design in black roughly crayoned on to it. This design matches the outline of the irregular cut already mentioned, but the shape is inverted, and also reversed. Both pieces of cardboard are contained in a kind of envelope made of transparent plastic, and this too is cut. The outline of the cut is a direct mirror image of the irregular curve sliced from the piece of card I have called the support. The flap which hangs down from it is in turn a mirror of that mirror, and thus corresponds with the original outline which supplies the rhythm of the whole composition. The correspondence is not, on this occasion, exact – the shape is subtly altered by the "spring" in the plastic as it falls forward, which shortens the original curve.

The hints of influence from Italian *pittura metafisica* to be found in Holland's work have already been mentioned, in connection with his paintings using milliner's models. A more developed example of this influence is *Screen* (57), where one of these models is combined with a semi-circular shape made from cardboard. This prop marks a step forward from the related painting where the model is combined with a blue tassel because the cardboard semi-circle helps to create the very real, yet "magical" space typical of Giorgio de Chirico's early paintings. This variety of *pittura metafisica* developed, as is well known, into the kind of Veristic Surrealism practiced by Salvador Dali and Yves Tanguy. There are allusions to this kind of work in Holland's still lifes of 1987–88.

A good example is *Poseidon* (58), in which the pictorial space of the painting is also to be thought of as a stage set, within which some kind of cryptic drama is taking place. The shallow space of Cubism, undefined at the edges, is here replaced by the kind of spatial enclosure familiar from Renaissance perspective exercises. The essentially theatrical nature of this device is made more obvious by the use of a kind of valance at the top of the composition. This emphasises the fact that what lies below it exists beyond a kind of window, a hole punched in the picture-plane. The form in the middle of the painting, standing in the centre of a black circle, is like an actor standing in a spotlight. Yet certain values are reversed. This form – the actor – which should logically be solid – is in fact transparent and ectoplasmic. The material of which it is made, once again transparent plastic, is so soft and boneless that there seems no compelling physical reason why

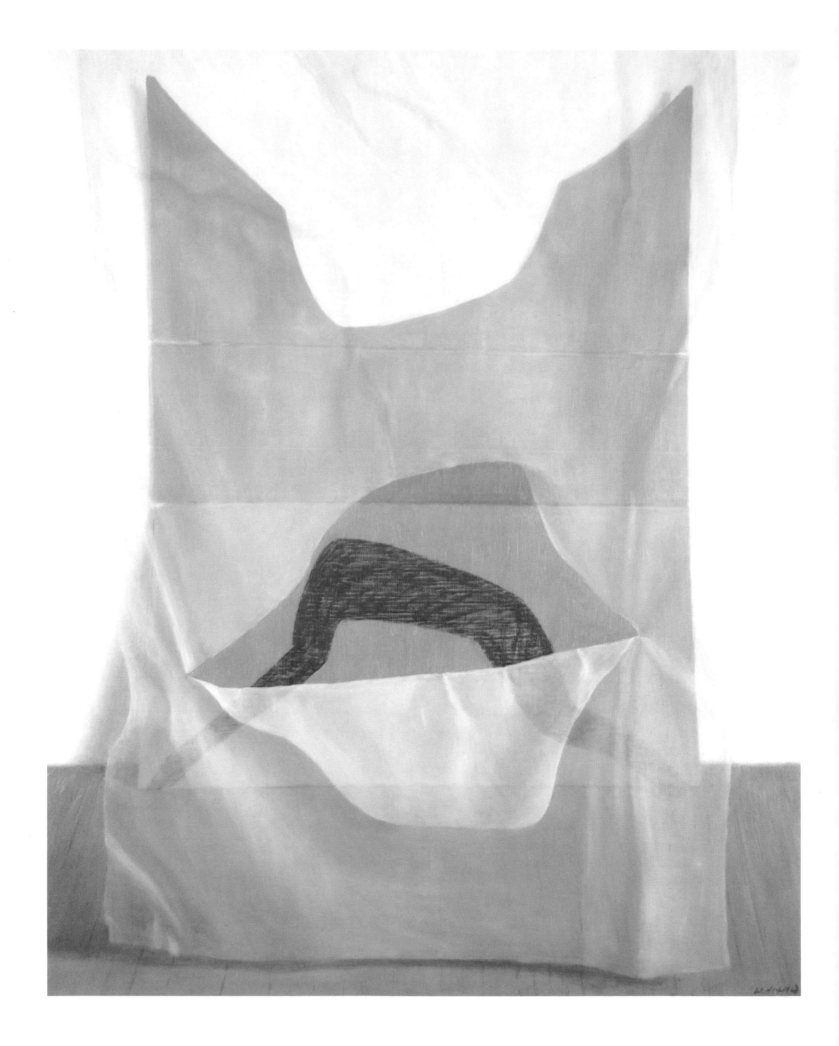

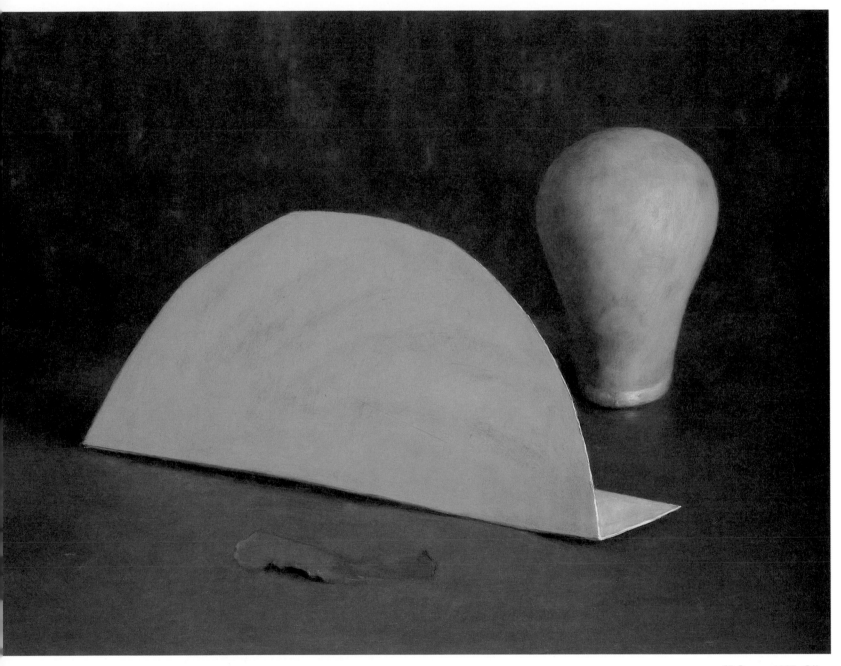

57 *Screen*. 1987. Oil on panel. (Private collection)

56 *Shadow*. 1988. Oil on canvas. (Contemporary Art Society)

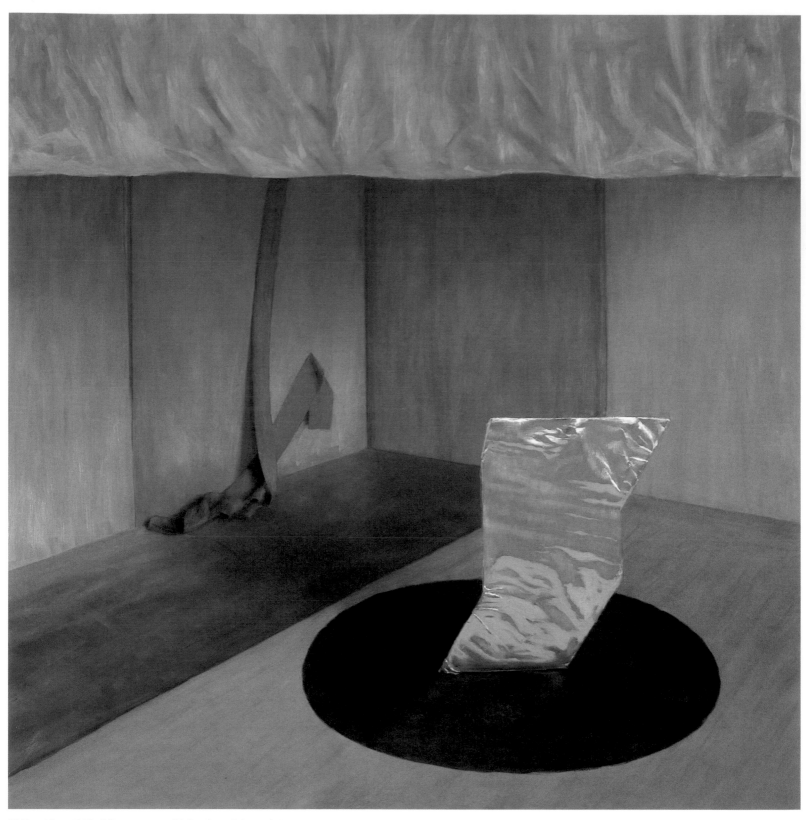

58 *Poseidon*. 1988. Oil on canvas. (Collection of the artist)

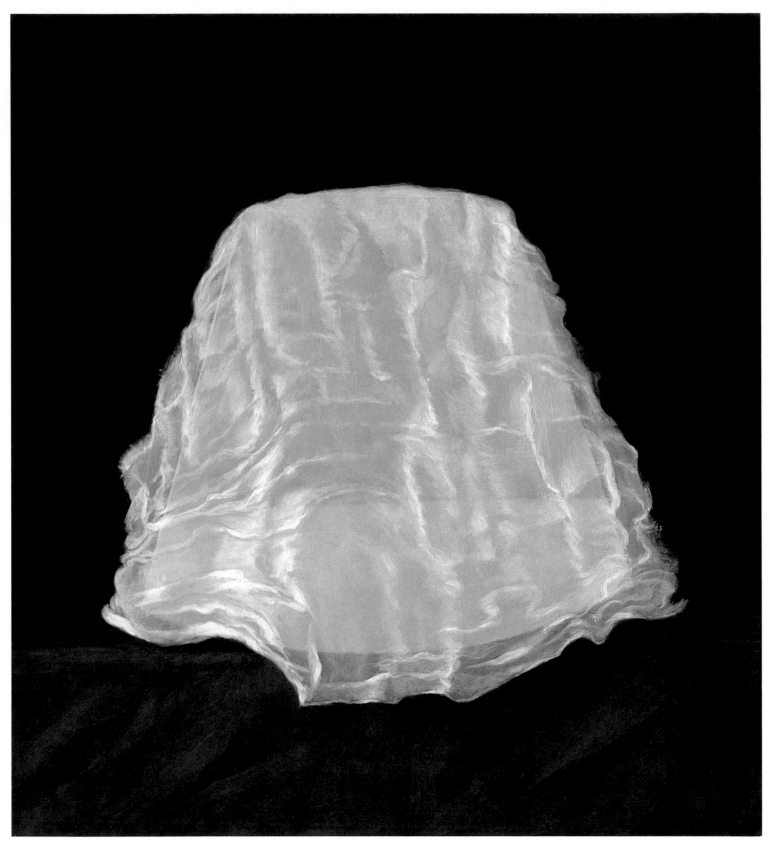

59 *Skirt*. 1988. Oil on panel. (Private collection)

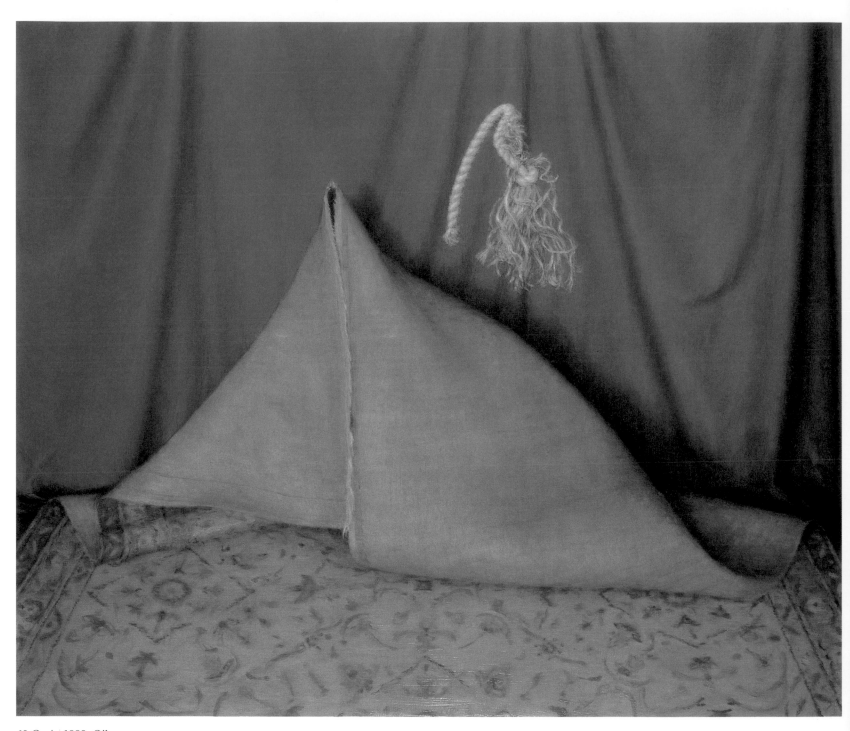

60 *Oasis*. 1988. Oil on
canvas. (Collection of
the artist)

it should stand upright in the way that it does. The "spotlight", on the other hand, is an area which is dark – the darkest in the whole picture – though it mimes the function of light.

Nevertheless a painting such as this one, with its residual narrative elements, seems more characteristic of what the artist was at this moment deserting, rather than what he was moving towards. More typical of the new direction is *Skirt* (59), painted in the same year as *Poseidon*. The essential thing about skirt is that it picks up the central motif of *Poseidon*, and pushes it to its limit: it presents a form made out of something which is essentially formless, in this case a thin piece of cloth. The material has none of the solidity of the twisted and bunched piece of carpet in *Oasis* (60), painted at about the same moment, and surprisingly reminiscent of some of the felt sculptures of the American Minimal sculptor Robert Morris. There is a remarkable passage in Paul Valery's book *Degas, Danse, Dessin* which describes what Holland is doing here:

> Let us suppose that we want to show something which is formless, but which nevertheless possesses a certain solidity. For example, I throw upon the surface of a table a handkerchief which I have crumpled up. The object doesn't look like, or resemble anything. The eye perceives it simply as disorderly folds. I cannot alter the position of one of its corners without changing that of the others. My problem is to make you see, when I draw it, a piece of cloth of a particular kind – with a particular flexibility and weight, which is all of a piece.
>
> I thus have to create an intelligible structure from an object which has no predetermined form, and where there is no visual convention or inherent memory to direct the work – as happens when one draws a tree, a human figure or an animal, all of which divide into different sectors or parts which are universally recognised. It is in this situation that the artist must exercise his intelligence, so that his eye finds, moving over what he is looking at, direction which his pencil can take on the paper. It is like the way in which a blind man feels his way, accumulating points of contact with a particular form, and thus acquiring little by little a knowledge of the unity of some regular solid.

This description (which can be linked to Holland's own description of the experience of painting the nude) gives some idea, not only of the actual difficulty of the exercise, but of the process of radical transformation which this kind of painting entails. The painter seizes reality at its most amorphous, and gives it not only form but design.

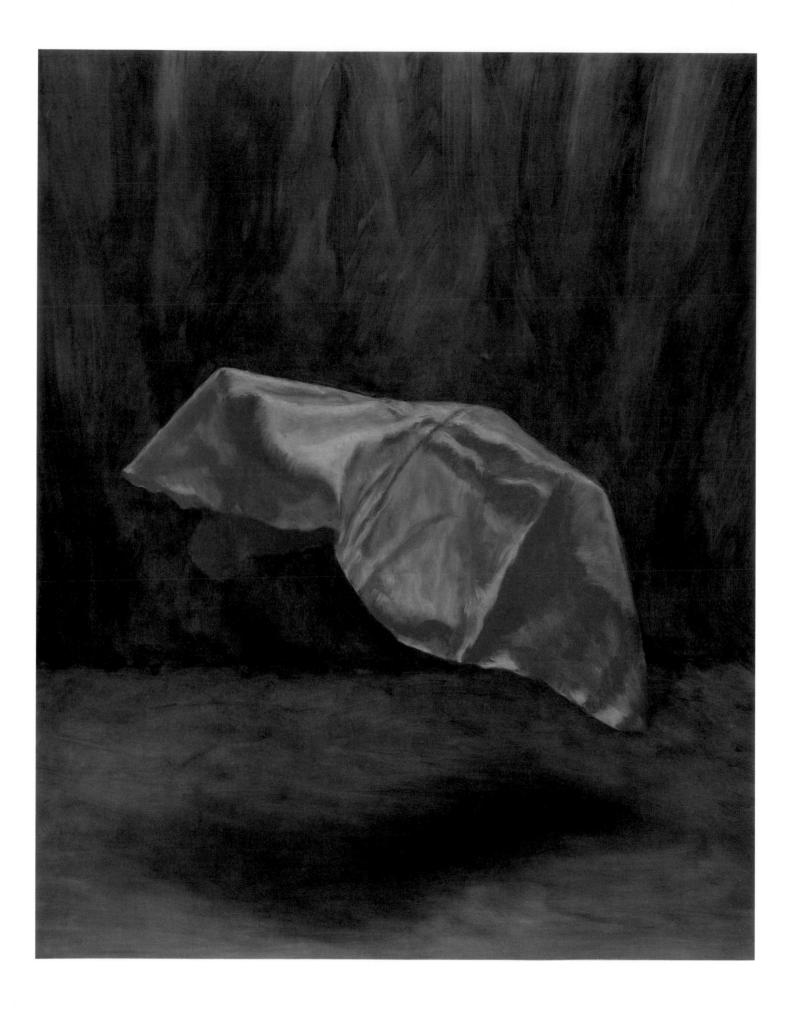

4

Not all of Holland's recent still lifes fall into this category, though a number of them certainly do (61, 62, 63). The residual interest in the dramatic or narrative (65, 66) which continued to show itself in 1987 and 1988 has now almost disappeared; so too has any fascination with quasi-surrealist conjunctions of objects (67). What is left is subject matter which is very simple; often almost completely minimal. Even the interest in seemingly complex conjunctions of form seems to dwindle. In terms of the recent work a painting like *Tail* (68) is quite a complicated compositional set up, though it would not have seemed so earlier.

Holland's tendency is more and more to study objects in isolation. Some are evidently chance finds of a sort he has now been using for some years, but now these appear to be chosen for their neutrality, for the absence of character rather than its presence (69, 70, 71, 72, 73, 74). Even a painting called *Statue* (75) depicts only a rough amorphous block. One is reminded of Michelangelo's remark that the statue already lives inside the stone.

A very few of these chance-found objects do have symbolic force. One or two paintings of large pebbles suggest, through the isolation of the object and the way in which the artist has positioned it, sculptures by Barbara Hepworth and other artists of the same generation (77, 78, 79). In one slightly atypical painting, two pebbles are placed in conjunction (80). In a couple of others, one sees a pebble and a flat metal shape, the latter vaguely humanoid (80, 81). In yet another, a similar flat shape is combined with a different pebble and a twig (82). In these the subliminal influence of Veristic Surrealism still persists, as it does even more obviously in a painting with three pebbles, one resting firmly on the ground, the other two floating unsupported in the air (83). This seems to be the descendant of a well-known series of paintings by Magritte, in each of which a vast boulder floats in mid-air above a landscape.

The humanoid shape just mentioned is clearly manufactured rather than found, and objects made *ad hoc* for inclusion in paintings have started to play a more and more prominent role in recent still lifes. Everything the artist says, and indeed the paintings themselves, make it plain that the objects do actually exist at some point, and are not imagined – this of course divides them immediately from such things as the soft watches which appear in Dali's compositions: the point of these, indeed, being that the artist makes us see things which cannot exist in reality. What Holland shows the spectator can and does exist.

61 *Go*. 1990. Oil on canvas. (Jill George Gallery)

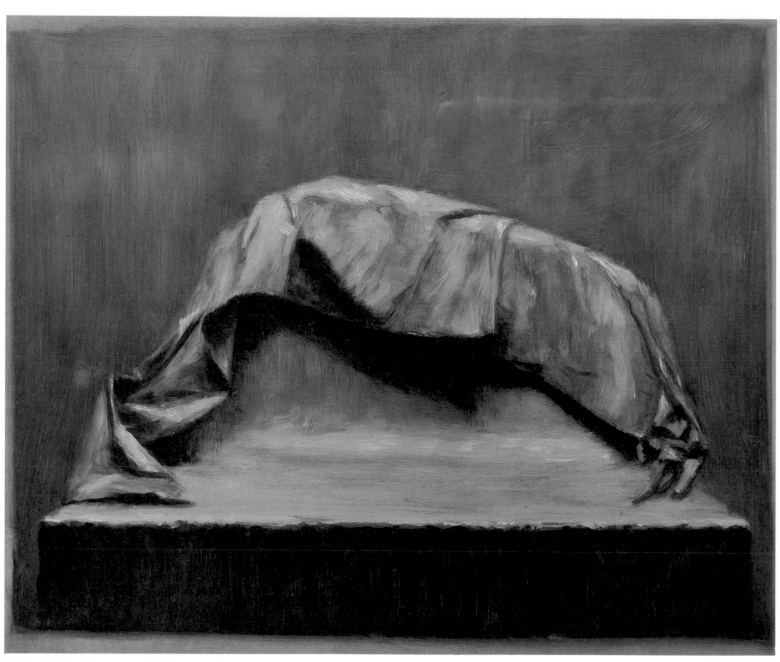

62 *Cloth*. 1990. Oil on panel. (Jill George Gallery)

63 *Line*. 1989. Oil on canvas. (Jill George Gallery)

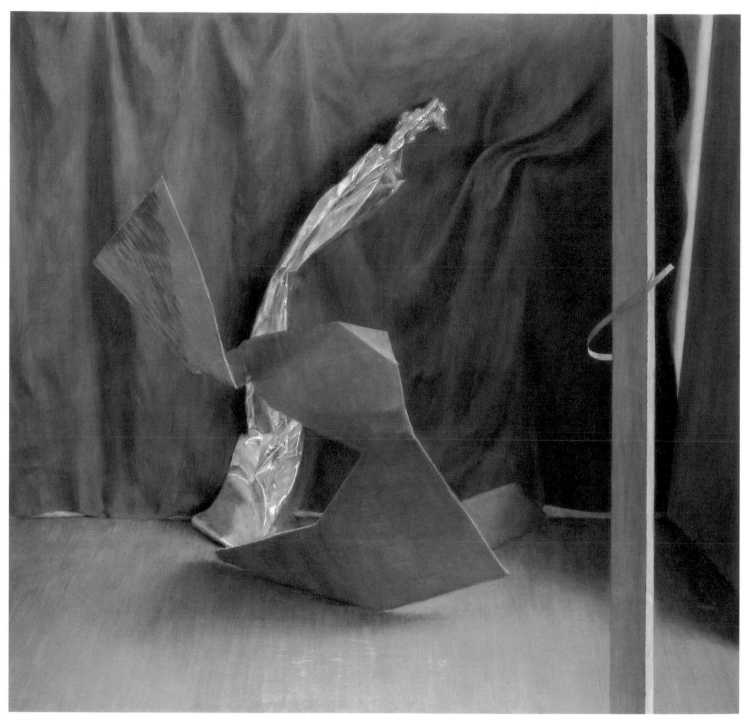

64 *Circus*. 1987. Oil on
canvas. (Private
collection)

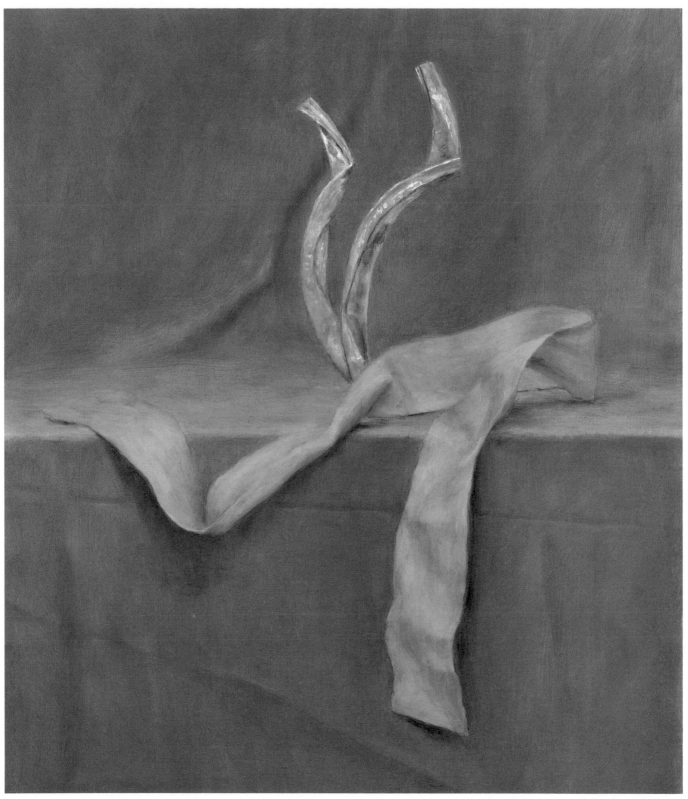

65 *Comb*. 1990. Oil on
panel. (Private
collection)

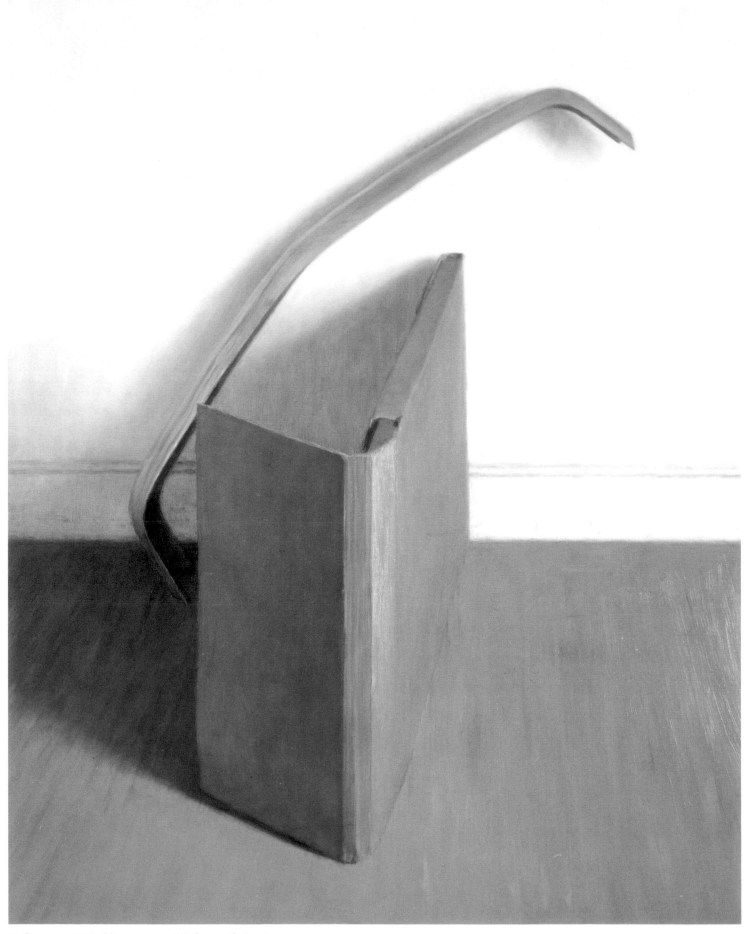

66 Construct. 1988. Oil on canvas. (Jill George Gallery)

67 *Tableaux*. 1988. Oil on canvas. (Jill George Gallery)

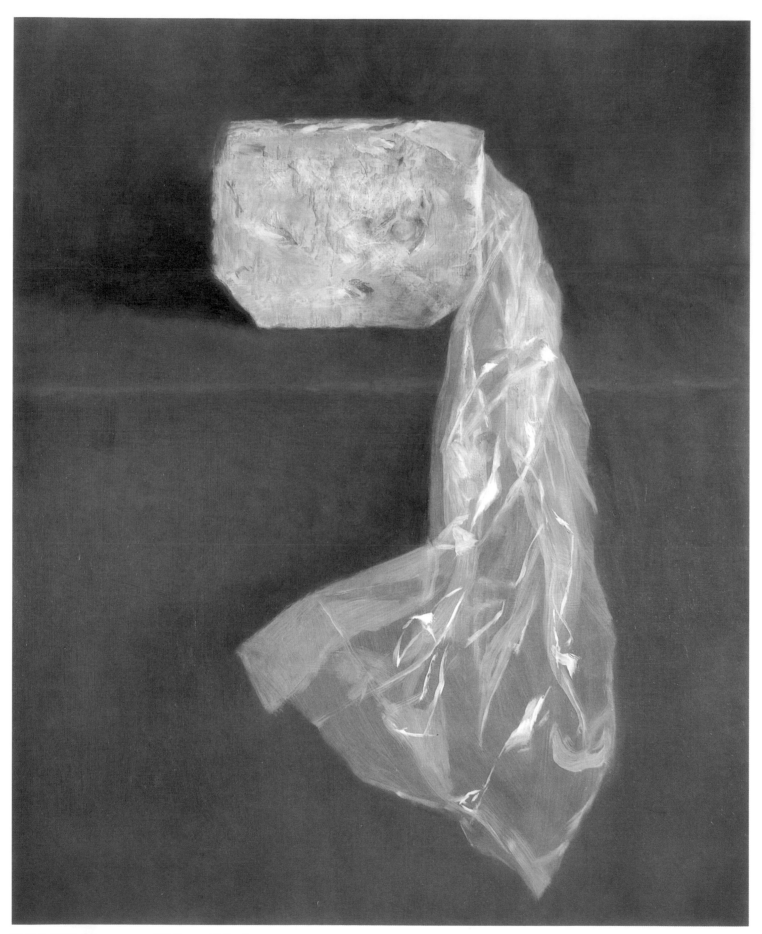

68 *Tail*. 1988. Oil on canvas. (Jill George Gallery)

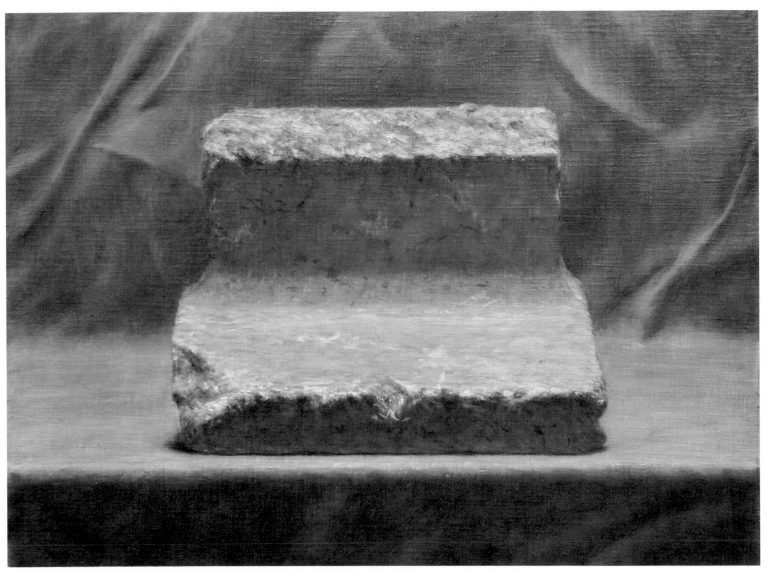

69 *Block*. 1989. Oil on panel. (Private collection)

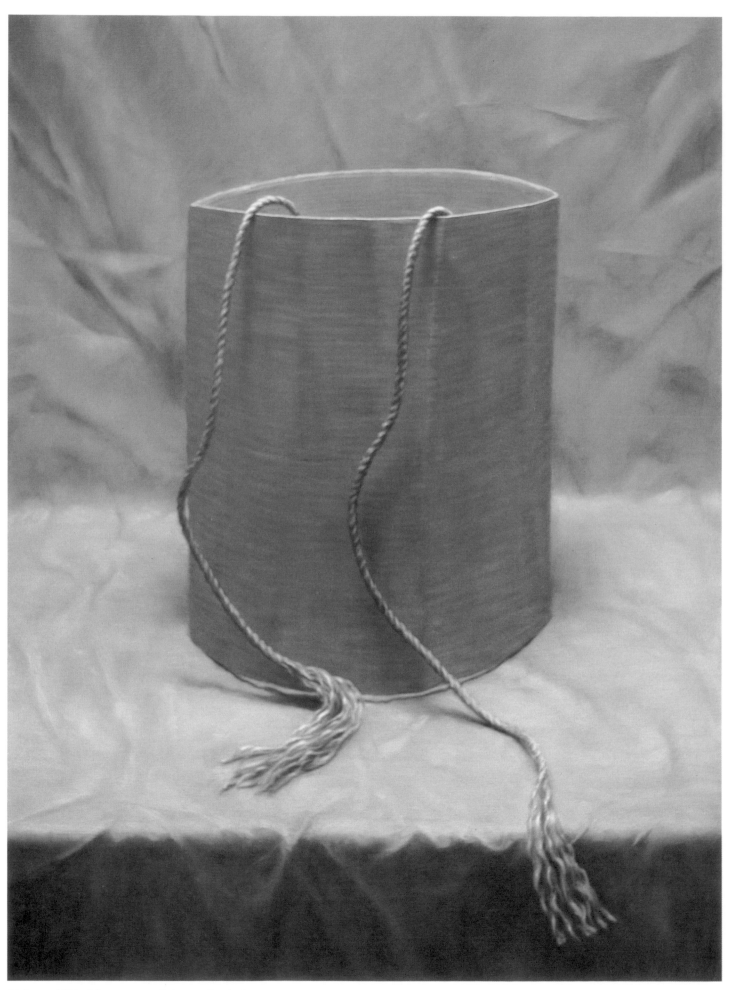

70 *Drum*. 1990. Oil on canvas. (Private collection)

71 *Stone*. 1990. Oil on canvas. (Jill George Gallery)

Some of the conjunctions found in his paintings, like *Tangle* (84), are obviously simple improvisations, created on the spot. Others, equally obviously, are much more deliberately created, though nearly always from "waste" and poor materials. Like the humanoid figure already mentioned, quite a large number of these creations take on vaguely anthropomorphic shapes. Some resemble the so-called "violin-shaped" idols produced by neolithic cultures in mainland Anatolia and in the Cyclades (85, 85a, 86, 87, 88, 89, 90). Holland is thus aligned with the strong current of influence from archaeology and from primitive art in general which has affected so many modernist artists. One near-contemporary of Holland's who has obviously looked closely at Anatolian idols is the British sculptor William Turnbull.

Other forms in Holland's new paintings suggest not whole bodies, but body parts. Two paintings depict a cardboard shape which suggests the form of a human leg (91, 92). A very similar shape can be found in the work of Henry Moore, who derived it from his own *Reclining Nudes*. Holland also makes use of a head shape, perhaps ultimately derived from the milliner's models (93). One composition turns directly to Hepworth for its inspiration – *House* (94) is a kind of parody of Hepworth's *Forms in Echelon*, with a transposition from positive to negative – that is, forms which are solid in the Hepworth sculpture are here presented as areas cut from pieces of cardboard. The same basic idea, with the same positive-to-negative twist, is used in *Branch* (95), though here the shapes are not Hepworth-like.

One interesting thing is that Holland expresses a certain hostility to sculpture of the Moore-Hepworth school. It is almost as if the still lifes which allude to sculpture of this sort are meant to be read as hostile statements. What was meant, by the sculptors, to seem archetypal and eternal, is sardonically restated in terms of ephemeral materials. Yet the paintings themselves are objects of impeccable craftsmanship.

A further link can be made between these manufactured forms fashioned from cardboard and other waste materials and *arte povera* – the Italian art movement of the late 1970s which took its name from the use of materials of this kind. For example, the objects represented in paintings such as *Arch* (96) or *Diviner* (97) would seem absolutely at home in an *arte povera* context – in themselves, that is. On the other hand the paintings in which they are represented clearly do not belong to it.

In addition, Holland has experimented with objects and constructs which refer to the ancestors of *arte povera*, in the established modernist line of descent. The mysterious rudimentary mechanism seen in *Hide* (99) can be referred to drawings by Picabia, and is also reminiscent of an assemblage entitled *God* made by the American Dadaist Morton Schamberg and now in the Philadelphia Museum of Art. The most influential Dadaist theoretician of them all, Marcel Duchamp, is present in spirit in paintings such as *Box* (100) and *Donkey* (101), and perhaps also in *Holder* (102), though the last of these can also be referred to the rather similar object in *Silo*, and offers a very good example of the way in which context, rather than the thing itself, can govern our reaction to a particular object. In fact, one can push this argument further. Presented just as they are in an exhibition context, an artist's

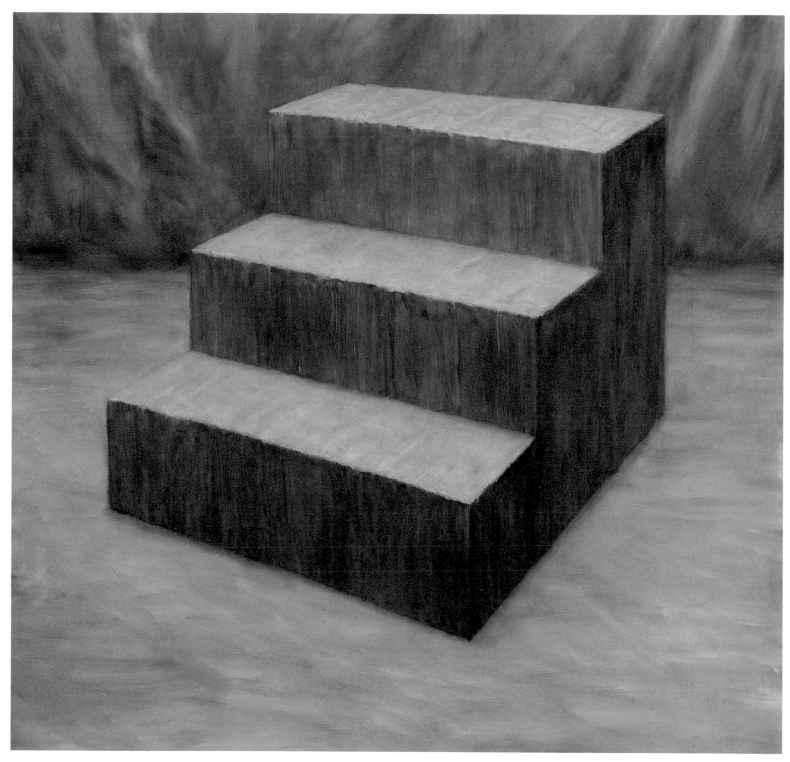

72 *Steps*. 1990. Oil on canvas. (Jill George Gallery)

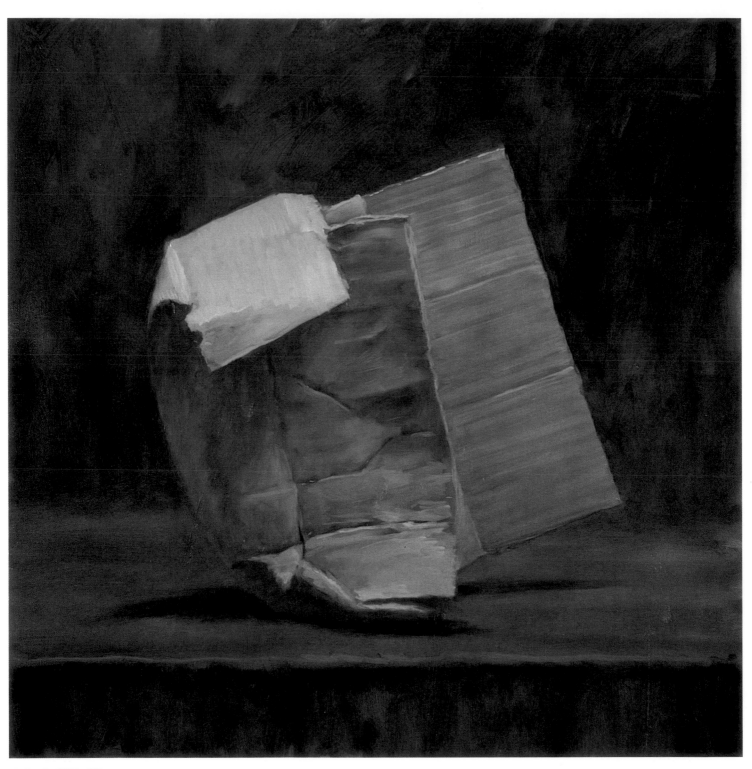

73 *Crush*. 1990. Oil on
canvas. (Private
collection)

74 *Skirt*. 1990. Oil on
canvas. (Private
collection)

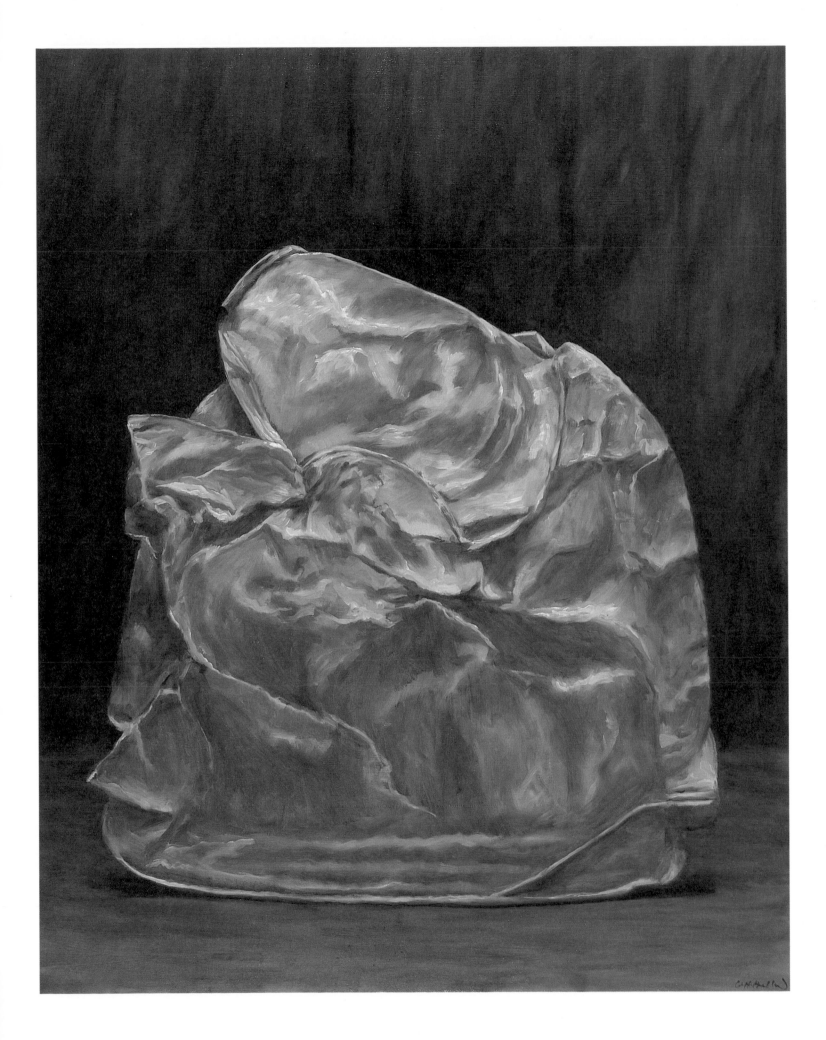

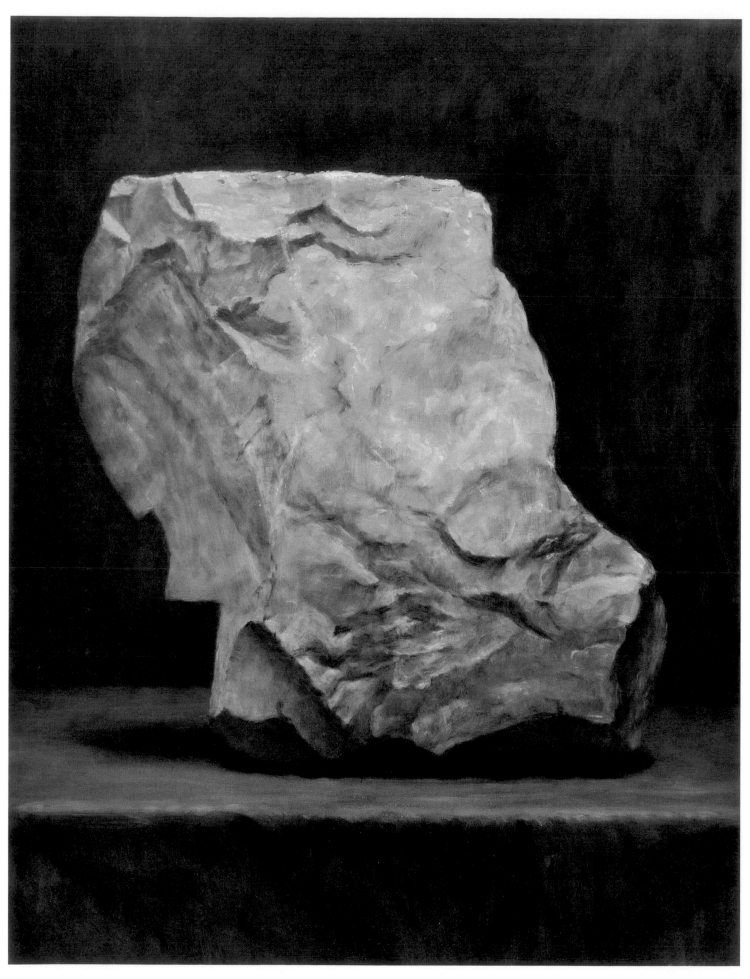

75 *Statue*. 1990. Oil on
canvas. (Jill George
Gallery)

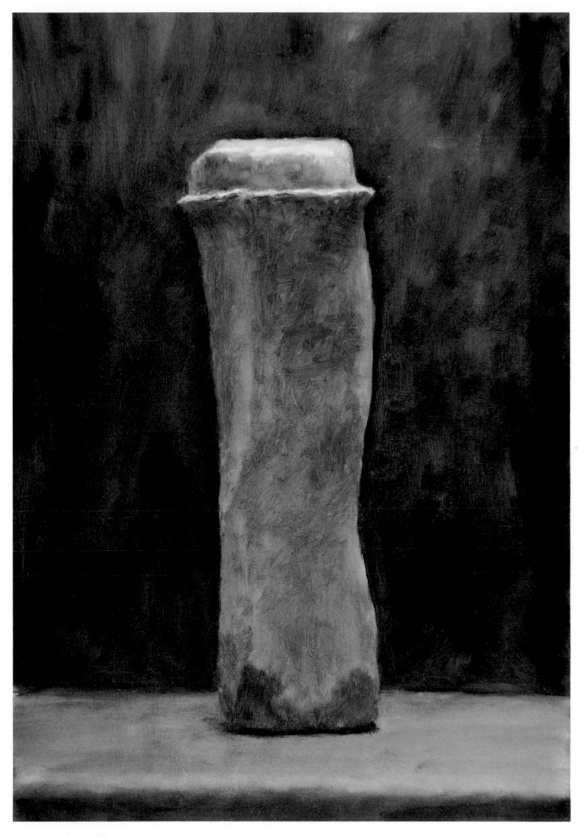

76 Pillar. 1990. Oil on
canvas. (Jill George
Gallery)

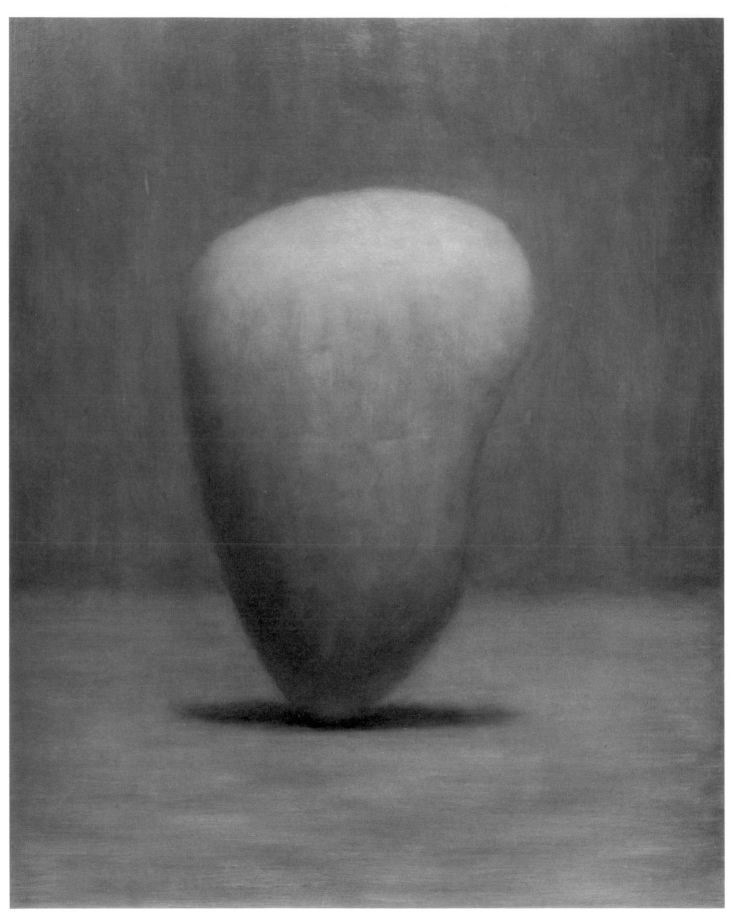

77 *Pebble*. 1989. Oil on panel. (Private collection)

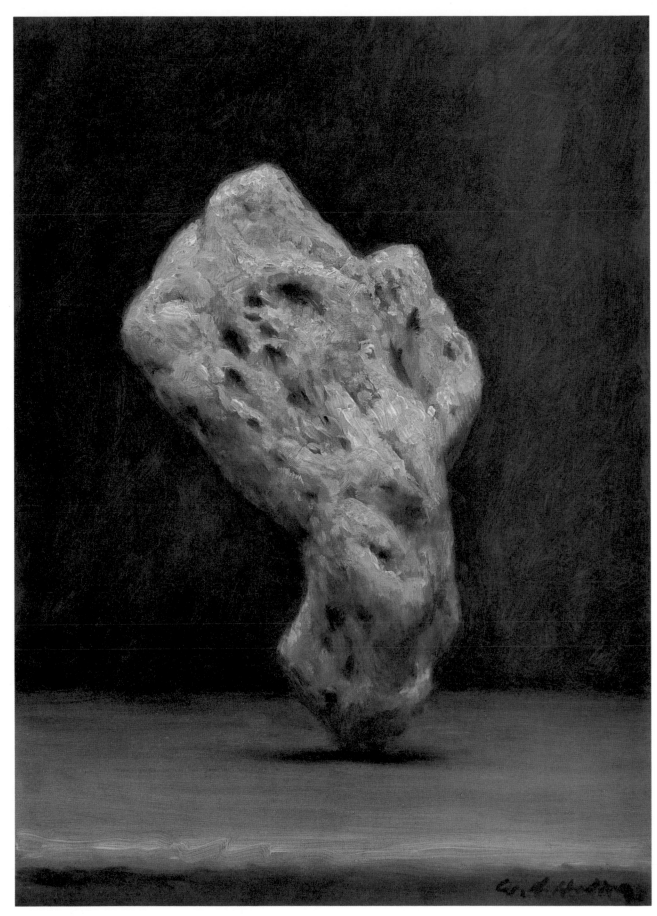

78 *Rock*. 1990. Oil on canvas. (Private collection)

donkey or a cardboard box would aspire to the resonance Duchamp imparted to his own found objects, such as *Bottlerack* or *Fountain* (a porcelain urinal presented as a piece of sculpture). Used as subject-matter for paintings, and especially paintings which represent (Holland would say copy) reality, they are at once transferred into a very different aesthetic universe.

It is the late paintings which demonstrate most clearly the special tensions and paradoxes which give Holland's work its particular flavour. Still life, and especially still life which contains an illusionist element, is often interpreted as being, simultaneously, a "naive" and a popular branch of painting. These two adjectives do not refer to precisely the same sets of qualities, though it is sometimes assumed that they do. Naiveté can imply an untutored way of painting. It can also imply an innocent way of seeing. Popular painting may be popular because it requires little visual sophistication on the viewer's part. It may also succeed because it conforms to certain stereotypes, embedded within the culture which provides the context for an encounter between spectator and work of art.

Holland's painting does, in one sense, try to get rid of preconceptions. The object or objects in front of the painter provide a fact or set of facts. He tries to translate these facts into his own language – a visual one – as precisely as he can. It is also true to say, however, that this language depends on a particular grammar, which in turn takes its dynamic from a set of visual conventions – accepted ways of perceiving the world – which have grown up over a long period.

In the paintings with figures Holland is, like many painters, but especially those to whom the term Post-Modernist is now often applied, in dialogue with ideas which belong to the whole past of European painting, from the Renaissance onwards. He is also, unavoidably, in dialogue with photography, a fact which is wryly acknowledged by the works which make the taking of photographs their subject. The assumption, in many if not all of these paintings, is that the spectator has some knowledge of art history. They work, in part, through triggering an associative process.

The still lifes, increasingly the major element in Holland's production, seem to concentrate much more specifically on a dialogue with Modernism, and indeed one can say that they wouldn't exist without the pre-existence of the Modern Movement. In my analysis of these works I have tried to demonstrate their links to many of the major High Modern art styles – to Cubism, to *pittura metafisica*, to various forms of Dada, and to the Veristic Surrealism of Tanguy and Magritte. I have also demonstrated the link to British 20th century sculpture and to the Italian *arte povera* of the 1970s. To understand the artist's relationship to and feelings about these exemplars, I think one has to refer to his account of his attitudes to the ruling clique of Conceptual artists when he was teaching at Coventry College of Art. What one detects in his account is affection, and even admiration of a sort (for what he describes as the "poetry" of their beliefs and formulations), but also an underlying scepticism and a profound sense of irony.

Artists who belong to the Modern Movement have often provided an ironic commentary on things which are pre-modern. This is the point, for example, of

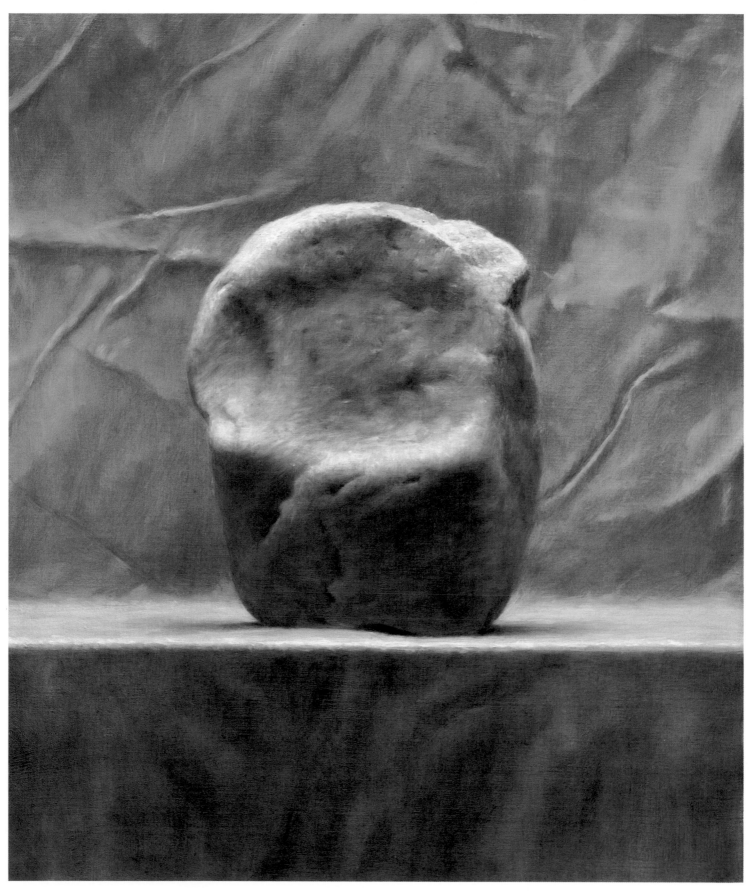

79 *Stone*. 1989. Oil on canvas. (Private collection)

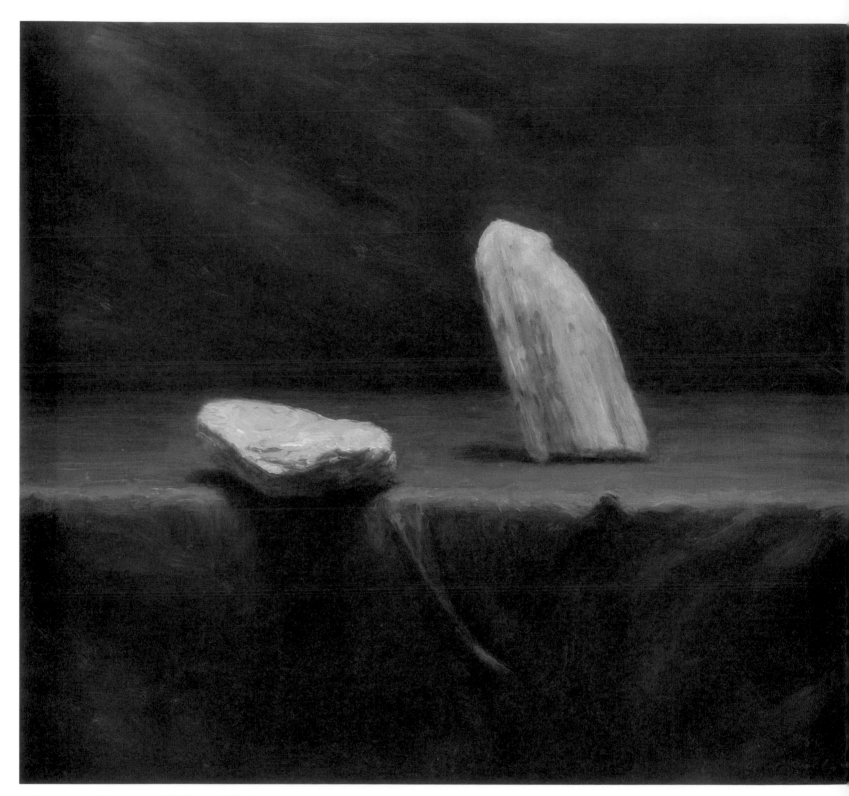

80 *Wait*. 1990. Oil on canvas. (Jill George Gallery)

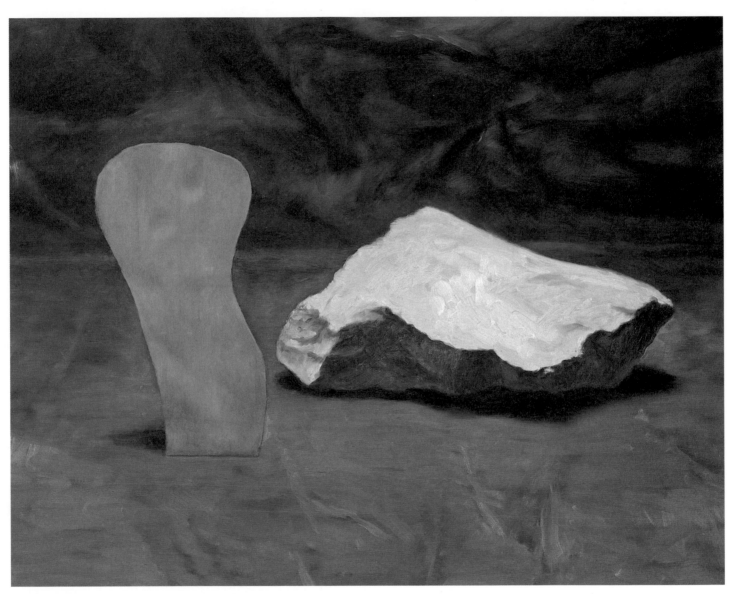

81 *Figure and Stone*. 1990. Oil on canvas. (Jill George Gallery)

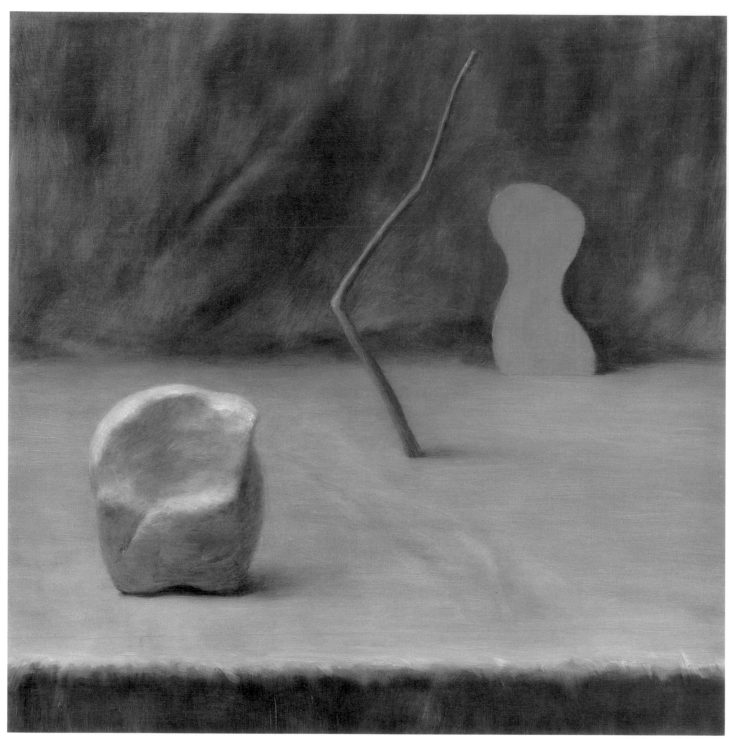

82 Glade. 1990. Oil on
canvas. (Private
collection)

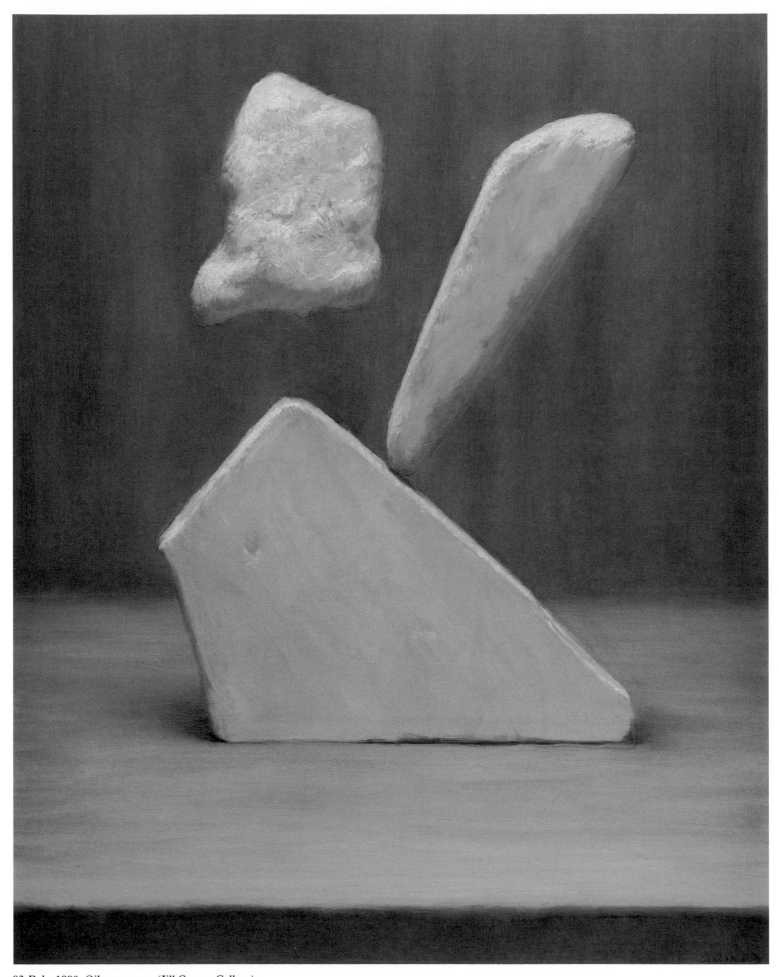

83 *Poly*. 1990. Oil on canvas. (Jill George Gallery)

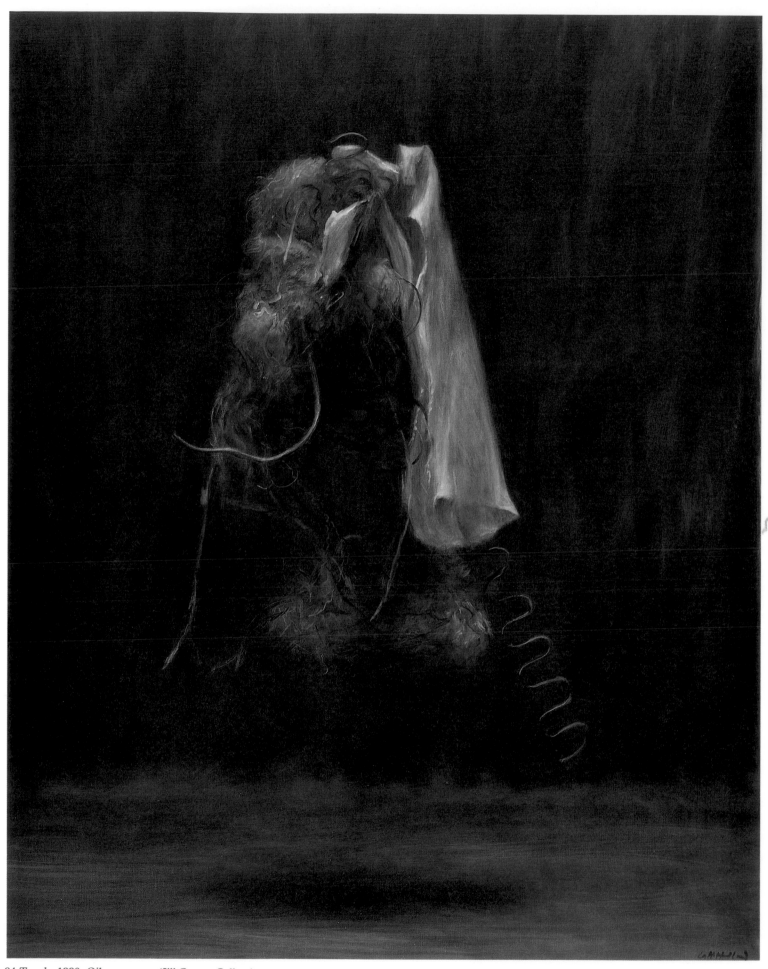

84 *Tangle*. 1990. Oil on canvas. (Jill George Gallery)

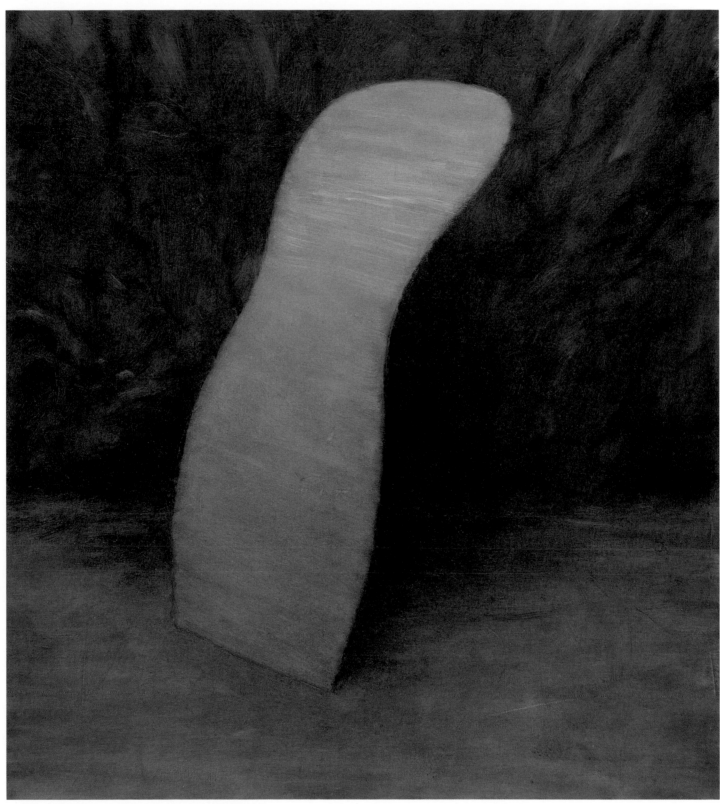

85 *Curve*. 1990. Oil on canvas. (Private collection)

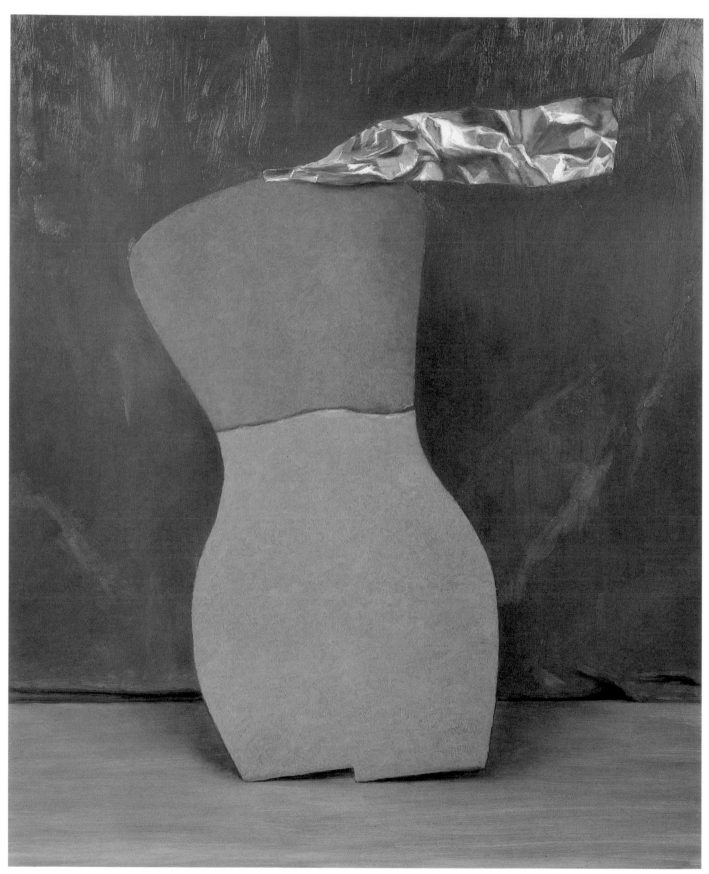

85a *Jill's Birthday*. 1989. Oil on panel. (Private collection)

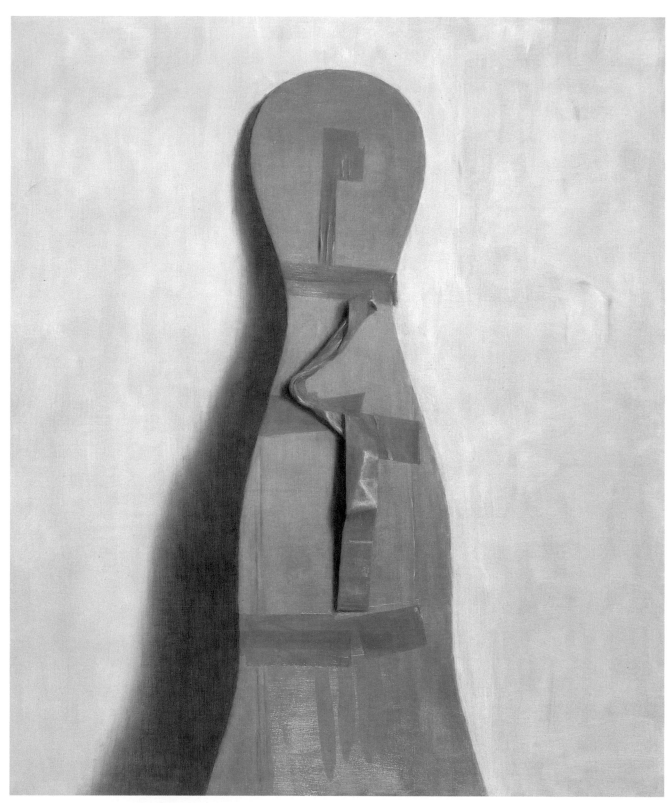

86 *Tail*. 1990. Oil on canvas. (Jill George Gallery)

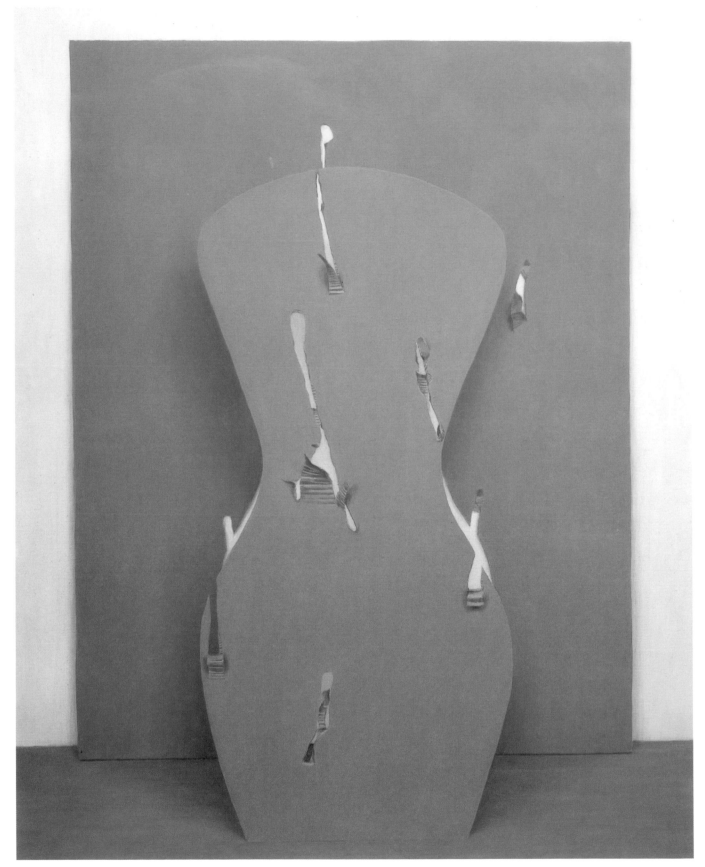

87 *Boa*. 1989. Oil on
canvas. (Jill George
Gallery)

88 *Persephone*. 1989.
Oil on canvas. (Jill
George Gallery)

89 *Line*. 1991. Oil on
canvas. (Jill George
Gallery)

90 *Figure*. 1991. Oil on
canvas. (Jill George
Gallery)

91 *Stone*. 1989. Oil on
panel. (Jill George
Gallery)

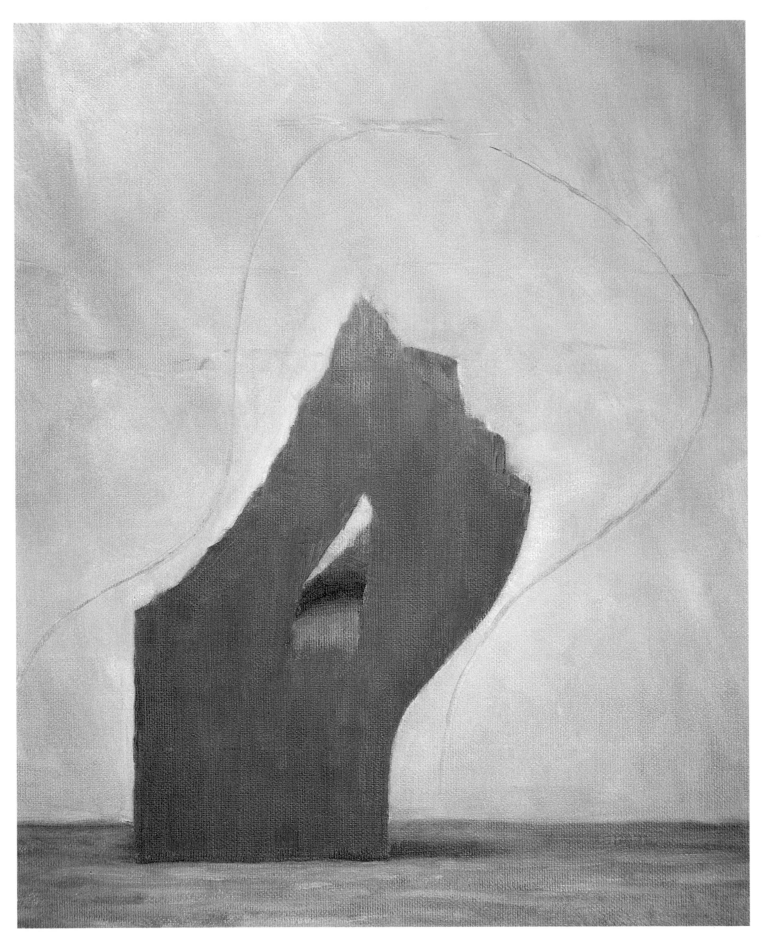

91a *Rhino*. 1991. Oil on canvas. (Jill George Gallery)

Max Ernst's use of Victorian engravings, which he cut up and rearranged so as to create the visual narrative of *La Semaine de Bonté* and other narratives of the same sort. What modernists are not accustomed to is being themselves the subject of ironic scrutiny.

This comment may leave the impression that I think the recent still lifes are primarily cerebral in their effect. This is very far from being the case. They are about the delight of seeing things, and of being able to render what one sees. The "minimality" of so much of the subject-matter is – but only incidentally – a hit at Minimal and Dadaist theories of modern art. The central thrust of the paintings is almost purely physical; it is about the processes of contemplating and gradually apprehending the essence of everyday reality. The Minimal artist, or the practitioner of *arte povera*, commands the spectator to focus on minimum forms and minimum material – but the artist does not participate in this focussing process, only creates the circumstances where it can take place. Holland's still lifes allow the audience to share the artist's own process of contemplation.

This process, however, must still be viewed within the context of the generically modernist sensibility. The still lifes, very obviously, would not look as they do if Modernism had never happened. The objects Holland chooses would not have been "there, waiting for him" at any previous epoch – not so much because so very many are industrial detritus, but because they would have been quite invisible to unschooled, pre-modern eyes. The kind of cogitation which creates these pictures is not precisely the same, self-evidently, as the process of cogitation which created the still lifes by the so-called *Peintres de la Réalité* in the France and Lorraine of the first half of the 17th century, even though valid comparisons can indeed be made between Holland and a painter like, for instance, Sébastien Stoskopff. The humility of Stoskopff's vision is, for one thing, still religious, while Holland's springs from an absence of illusion (in the more metaphysical sense of that noun) – what one might almost call a spiritual void.

Modernism was conspicuous, throughout its history, for its enthusiasm for ideologies. Some of these ideologies were purely artistic, others were political – witness the long and abortive romance between the Surrealist Movement and Communism. Holland's painting, like other recent art, is post-modernist in a profound rather than a glib sense because of its profound scepticism about ideological commitment, which also incorporates a feeling of nostalgia for that sense of belonging which all creeds, including this one, confer on their adherents.

Nevertheless, the artist could not have reached his present position without direct personal experience of some phases of the modernist adventure, most notably the revival of Dada and the rise of Conceptual Art. Dada, in particular, set form to demolish existing artistic ideologies and succeeded in becoming an ideology in its own right – the still lifes illustrated here often give fragmentary reflections of this process, while at the same time stressing the importance of the "given" in quite a different sense. Their true subject is the intractable thereness and otherness of reality.

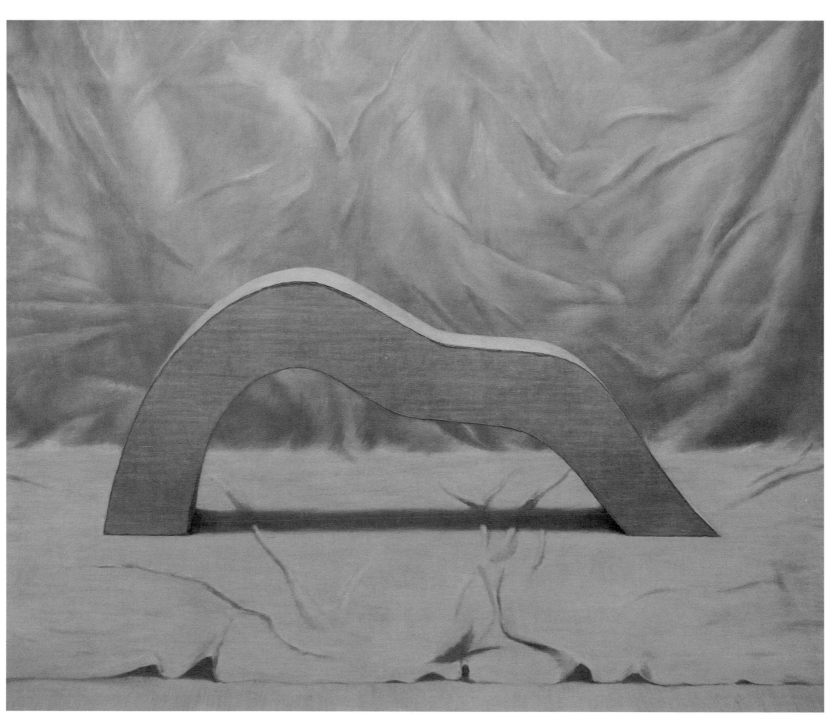

92 *Actaeon*. 1990. Oil on canvas. (Private collection)

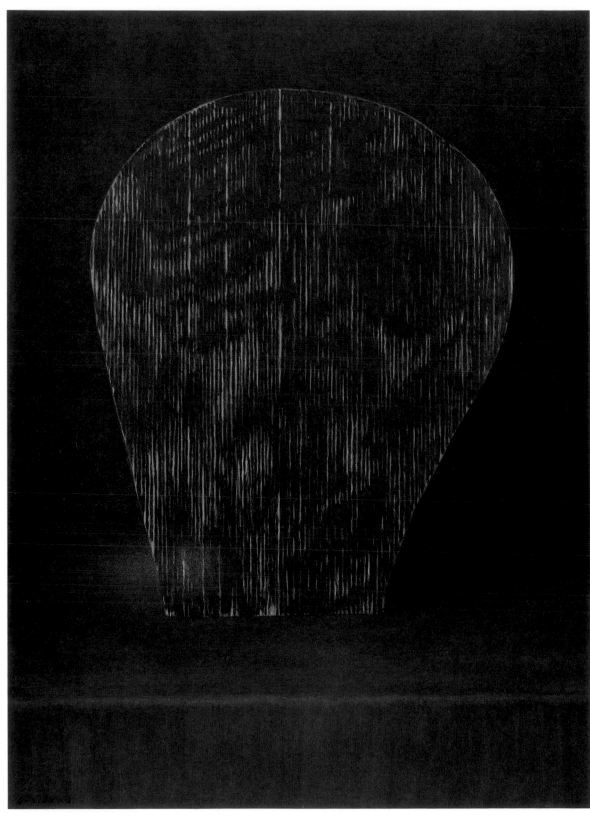

93 *Cypher*. 1988. Oil
on panel. (Collection
of the artist)

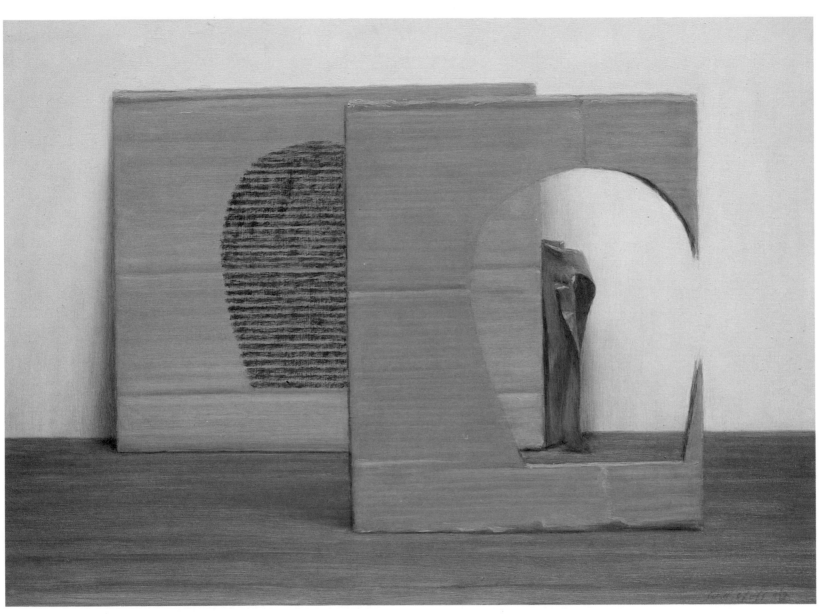

94 *House*. 1989. Oil on panel. (Private collection)

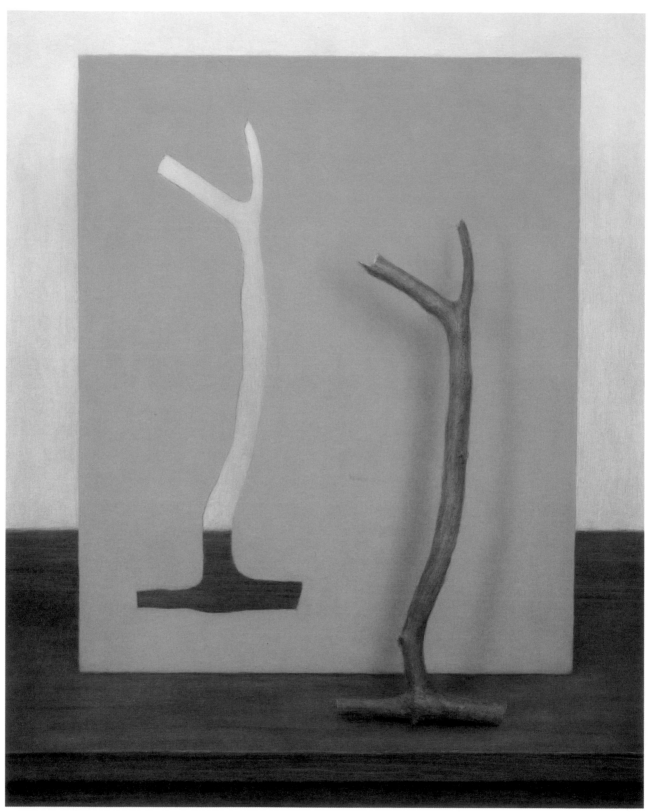

95 *Branch*. 1989. Oil
on canvas. (Private
collection)

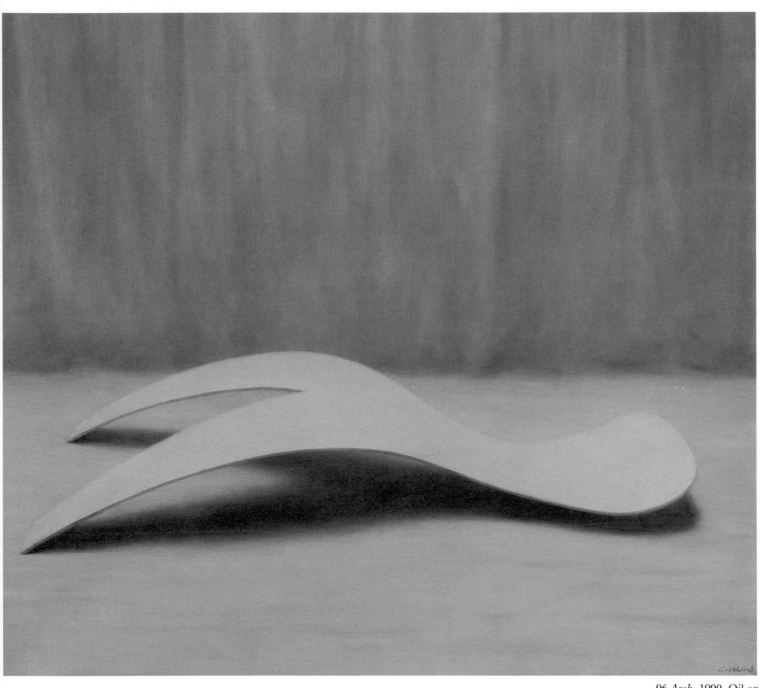

96 *Arch.* 1990. Oil on canvas. (Private collection)

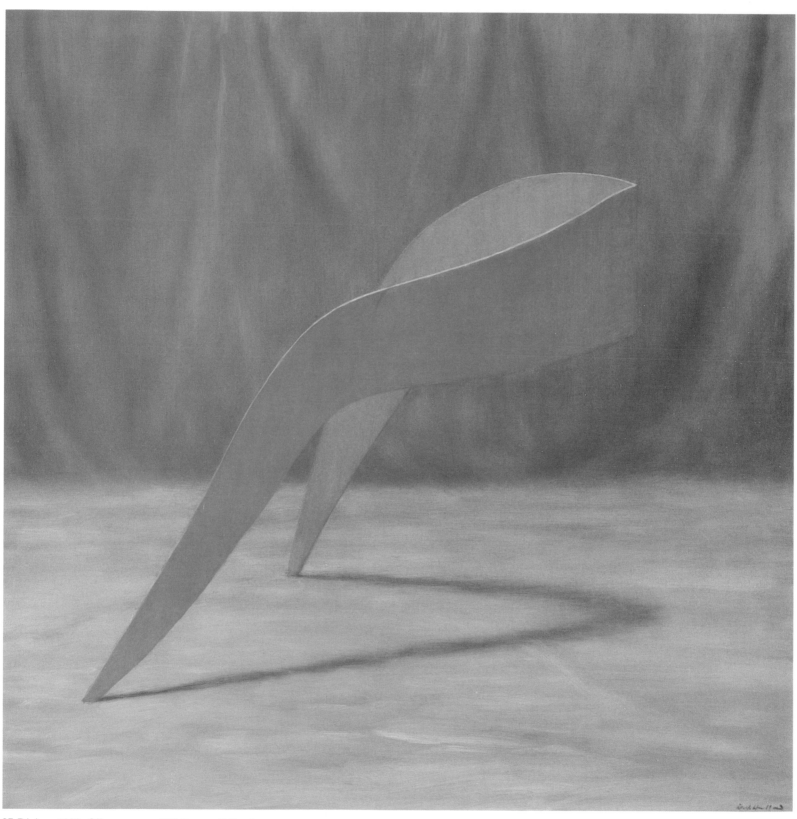

97 *Diviner*. 1990. Oil on canvas. (Jill George Gallery)

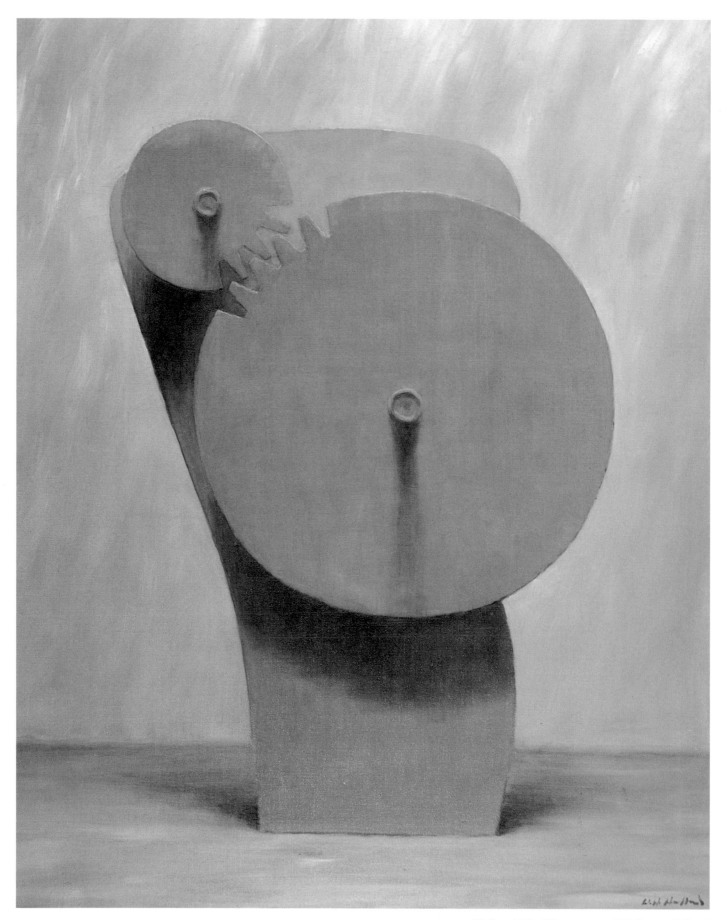

98 *Coq.* 1991. Oil on canvas. (Jill George Gallery)

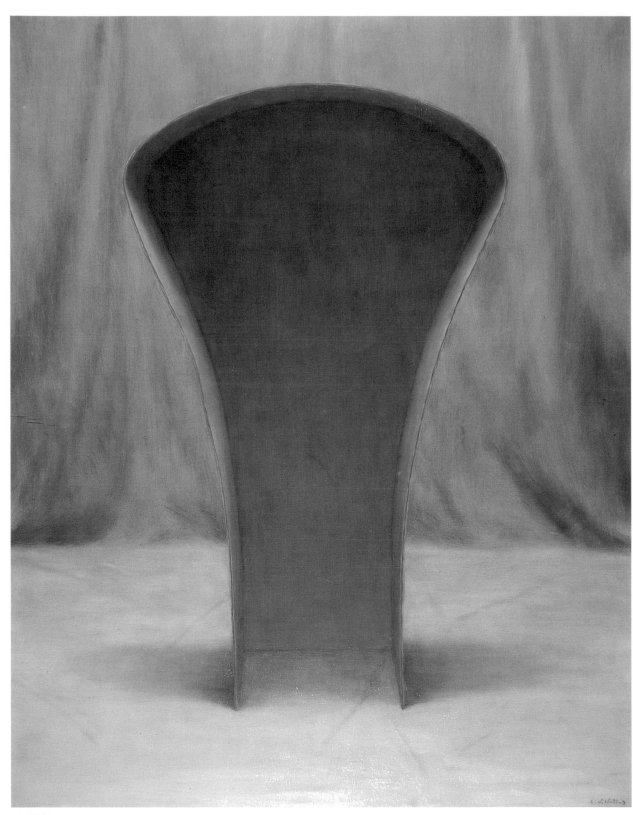

99 *Hide.* 1989. Oil on canvas. (Jill George Gallery)

One of the qualities which doctrinaire modernism notoriously does not possess is charm. One consequence of Harry Holland's love of the materials and techniques he uses, and indeed of the whole process of creating images on canvas, is that his work – and perhaps most of all the still lifes discussed in this final section – possesses this quality in abundance. Its influence is the more profound because it so clearly does not arise from specific subject matter, but from the painter's whole relationship with reality itself.

Essentially what Holland has done is to invent a new future and a new function for the traditional still life. One of the curiosities of the history of this particular genre is the fact that it has always been involved with metaphysics. The first still lifes, at least the first in the Christian tradition, were isolated presentations of objects which had a religious significance. In the 17th century this widened to encompass the notion of the *Vanitas* – by presenting material things in an extremely concrete and specific way, the artist emphasised the transience of human existence. This undertone remained even when the specific symbols associated with the *Vanitas* – the skull, the hourglass, the pocket watch – were not in fact present.

Chardin's still lifes represent a kind of psychological turning point. Closely linked, in many respects, with their 17th century predecessors, they seem, nevertheless, to deny the transcendental element. A Chardin of kitchen utensils prefigures Wittgenstein's famous formulation: "The world is everything that is the case". Yet, by focusing the mind so relentlessly on the materiality of things, Chardin's paintings also lead the mind beyond what is purely material: it is the spectator's relationship with reality, his or her willingness to accept the intractable nature of physical experience, which becomes the subject of the picture.

In Holland's recent paintings, the material world is once again dissolving – but in a rather specialised sense. Chardin's objects are reassuringly solid, the products of the handcraftsman, fit for repeated everyday use. Holland's are simply debris, the discards of industrial civilisation. One of the characteristics of a fully industrial culture, as opposed to one in which the artisan is the central figure, is that the object is now entirely subsumed in its function. That is, a television set attains its full identity only when it is switched on, and actually transmitting a programme. Chardin's utensils are forever ready for use; Holland's fragments are useless, already on the road to nothingness. This is one of the things which gives the still lifes their special frisson. Despite their concreteness, it is their celebration of nothingness, the flirtation with the void, that makes them memorable.

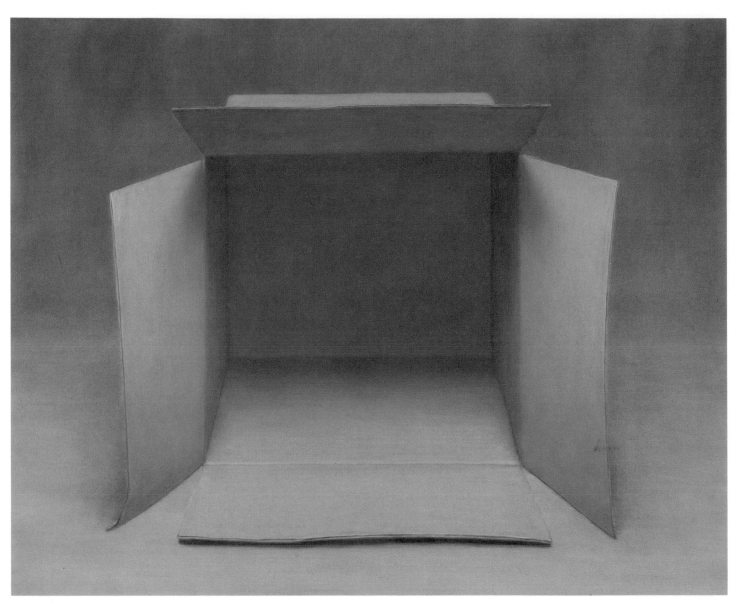

100 *Box*. 1990. Oil on
canvas. (Private
collection)

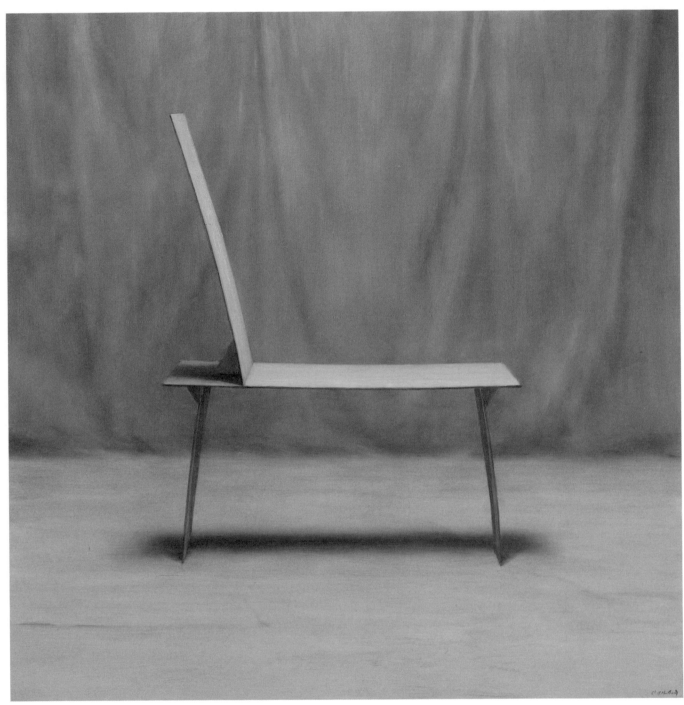

101 *Donkey*. 1990. Oil
on canvas. (Private
collection)

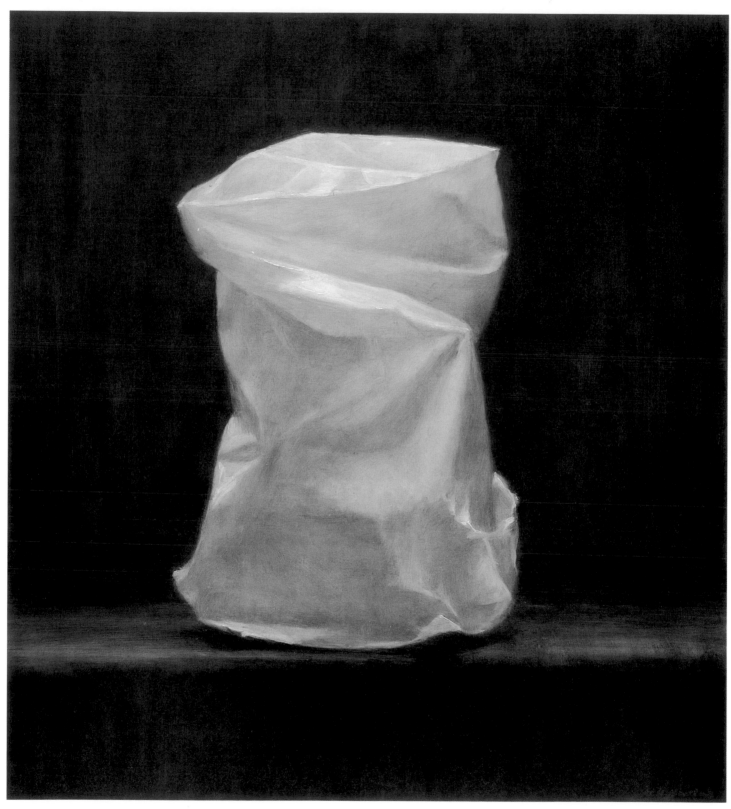

102 *Holder*. 1990. Oil on canvas. (Jill George Gallery)

ARTIST'S BIOGRAPHY

1941 Born in Glasgow
1965–1969 St. Martin's School of Art

One-Man Exhibitions

1979 Roundhouse Gallery, London
 Oriel Gallery, Cardiff
 Midland Group Gallery, Nottingham
1980 *Harry Holland*, Welsh Arts Council Touring Exhibition
1981 Mineta Move Gallery, Brussels
1982 Robin Garton Gallery, London
 Arnold Katzen Gallery, New York
1983 FIAC, Paris, Mineta Move
 Robin Garton Gallery, London
1984 Ian Birkstead Gallery, London
 FIAC, Paris, Mineta Move
1985 Artsite Gallery, Bath
 Edinburgh Demarcations, Garton and Cooke
1986 Chicago Art Fair, Ian Birkstead Gallery
 New Drawings, Birkstead Gallery, London
1987 Andrew Knight Gallery, Cardiff
 Bohun Gallery, Henley-on-Thames
1988 Thumb Gallery, London
 Garton and Co., London
1989 Bohun Gallery, Henley-on-Thames
 Forum Art Fair, Hamburg (Thumb Gallery)
1990 Thumb Gallery, London
1991 Jill George Gallery, London
 UK Travelling Retrospective

Group Exhibitions

1976–78 *Aspects of Realism*, Touring Exhibition to 13 Canadian Cities
1977 *From Wales* (selected by Rollo Charles), Fruitmarket Gallery, Edinburgh
1978 National Eisteddford of Wales (prizewinner)
1979 *Grandes et Jeunes d'aujourd'hui*, Grand Palais, Paris
1980 *Probity of Art* (selected by Patrick Dolan), Welsh Arts Council Touring
 Exhibition, Wales and Spain
 British Art Show (selected by William Packer), Arts Council of Great Britain
 Touring Exhibition

1981	*Art of the Eighties*, Walker Art Gallery, London
1983	European Print Biennale, Heidelberg
	The Male Nude (selected by Edward Lucie-Smith), Ebury Gallery, London
1984	Bradford Print Biennale
1985	2nd International Art Fair, London
1986/87/88	International Contemporary Art Fair, Los Angeles (Thumb Gallery)
1987	Bruton Gallery, Bruton
	Self-Portrait – A Modern View, Touring Exhibition
1988	The Drawing Show, Thumb Gallery, London
1989	*Ways of Telling*, Mostyn Gallery, Wales
	People in Great Britain, British Council Travelling Exhibition
	4th International Contemporary Art Fair, Los Angeles (Thumb Gallery)
	Art London, London (Thumb Gallery)
	Graham Modern Gallery, New York
1990	Art '90, London (Thumb Gallery)
	London to Atlanta, Atlanta, USA
	The Drawing Show II, Thumb Gallery, London
	5th International Art Fair, Los Angeles (Thumb Gallery)
1991	Art '91, London (Thumb Gallery)
	Decouvertes, Paris (Thumb Gallery)
	Art London '91, Olympia, London (Jill George Gallery)

Selected Public Collections

Contemporary Art Society
Tate Gallery, London
Newport Museum and Art Gallery, Newport
National Museum of Wales, Cardiff
Welsh Arts Council
Contemporary Arts Society for Wales
Metropolitan Museum of Art, New York
Heineken Collection, Amsterdam
European Parliament Collection
Belgian National Collection
Fitzwilliam Museum, Cambridge

Commissions

Cardiff City Council: Cardiff Castle Mural
Greater London Council: Portrait of Iltyd Harrington, Chairman ILEA
Welsh Arts Council: Print commission (The Final Proof exhibition)
Portrait of Lord Callaghan

INDEX OF WORK

134

28 *Flier*. 1986
oil on canvas
60 x 60 inches/150 x 150cm
Private collection, UK

29 *Cloth*. 1987
oil on panel
17 x 20 inches/42.5 x 50cm
Private collection, USA

29a *Still Nude*. 1987
oil on panel
16 x 12 inches/40 x 30cm
Private collection, UK

30 *Mirror*. 1987
oil on panel
18 x 12 inches/45 x 30cm
Private collection, UK

31 *Ribbon*. 1987
oil on panel
24 x 20 inches/60 x 50cm
Private collection, UK

32 *Mirror*. 1986
oil on panel
11 x 16 inches/27.5 x 40cm
Private collection, UK

33 *Bone*. 1982
oil on panel
8 x 9 inches/20 x 22.5cm
Collection of the artist

34 *Study*. 1982
oil on panel
9 x 12 inches/22.5 x 30cm
Private collection, USA

35 *Camera*. 1982
oil on panel
12 x 12 inches/30 x 30cm
Private collection, USA

36 *Camera*. 1982
oil on panel
12 x 10 inches/30 x 25cm
Private collection, USA

37 *Still Life*. 1981
oil on panel
14 x 18 inches/35 x 45cm
Private collection, USA

38 *Still Life*. 1981
oil on panel
12 x 18 inches/30 x 45cm
Private collection, USA

39 *Foil*. 1982
oil on panel
8 x 11 inches/20 x 27.5cm
Private collection, UK

40 *Skull*. 1984
oil on panel
12 x 12 inches/30 x 30cm
Private collection, UK

41 *Cup and Cloth*. 1986
oil on panel
10 x 15 inches/25 x 37.5cm
Private collection, UK

42 *Mannequin*. 1986
oil on panel
11 x 12 inches/27.5 x 30cm
Private collection, USA

43 *Milliner's Model*. 1984
oil on panel
12 x 10 inches/30 x 25cm
Private collection, UK

44 *Milliner's Model*. 1984
oil on panel
14 x 12 inches/35 x 30cm
Collection of the artist

45 *Model*. 1987
oil on panel
32 x 24 inches/80 x 60cm
Private collection, USA

46 *Fence*. 1986
oil on panel
12 x 14 inches/30 x 35cm
Collection of the artist

47 *Brick*. 1986
oil on panel
12 x 14 inches/30 x 35cm
Private collection, UK

48 *Wing Mirror*. 1986
oil on panel
24 x 23 inches/60 x 57.5cm
Private collection, UK

49 *Box*. 1987
oil on canvas
48 x 39 inches/120 x 97.5cm
Private collection, UK

50 *Ribbon*. 1987
oil on canvas
55 x 42 inches/137.5 x 105cm
National Museum of Wales

51 *Study*. 1986
oil on panel
12 x 12 inches/30 x 30cm
Private collection, UK

52 *Doll*. 1982
oil on panel
7 x 8 inches/17.5 x 20cm
Private collection, UK

53 *Priest*. 1988
oil on canvas
66 x 54 inches/165 x 135cm
Collection of the artist

54 *Curtain*. 1987
oil on panel
32 x 24 inches/80 x 60cm
Private collection, UK

55 *Stall*. 1988
oil on canvas
60 x 72 inches/150 x 180cm
Collection of the artist

56 *Shadow*. 1988
oil on canvas
60 x 48 inches/150 x 120cm
Contemporary Art Society

57 *Screen*. 1987
oil on panel
24 x 32 inches/60 x 80cm
Private collection, UK

58 *Poseidon*. 1988
oil on canvas
72 x 72 inches/180 x 180cm
Collection of the artist

59 *Skirt*. 1988
oil on panel
24 x 22 inches/60 x 55cm
Private collection, UK

60 *Oasis*. 1988
oil on canvas
60 x 48 inches/150 x 120cm
Collection of the artist

61 *Go*. 1990
oil on canvas
60 x 48 inches/150 x 120cm
Jill George Gallery, London

62 *Cloth*. 1990
oil on panel
8 x 10 inches/20 x 25cm
Jill George Gallery, London

63 *Line*. 1989
oil on canvas
48 x 48 inches/120 x 120cm
Jill George Gallery, London

64 *Circus*. 1987
oil on canvas
60 x 66 inches/150 x 165cm
Private collection, UK

65 *Comb*. 1990
oil on panel
32 x 24 inches/80 x 60cm
Private collection, UK

66 *Construct*. 1988
oil on canvas
48 x 36 inches/120 x 90cm
Jill George Gallery, London

67 *Tableaux*. 1988
oil on canvas
60 x 48 inches/150 x 120cm
Jill George Gallery, London

68 *Tail*. 1988
oil on canvas
32 x 24 inches/80 x 60cm
Jill George Gallery, London

69 *Block*. 1989
oil on panel
14 x 20 inches/35 x 50cm
Private collection, UK

70 *Drum*. 1990
oil on canvas
48 x 36 inches/120 x 90cm
Private collection, UK

71 *Stone*. 1990
oil on canvas
12 x 8 inches/30 x 20cm
Jill George Gallery, London

72 *Steps*. 1990
oil on canvas
48 x 48 inches/120 x 120cm
Jill George Gallery, London

73 *Crush*. 1990
oil on canvas
36 x 36 inches/90 x 90cm
Private collection, UK

74 *Skirt*. 1990
oil on canvas
60 x 48 inches/150 x 120cm
Private collection, UK

75 *Statue*. 1990
oil on canvas
36 x 26 inches/90 x 65cm
Jill George Gallery, London

76 *Pillar*. 1990
oil on canvas
16 x 12 inches/40 x 30cm
Jill George Gallery, London

77 *Pebble*. 1989
oil on panel
12 x 10 inches/30 x 25cm
Private collection, UK

78 *Rock*. 1990
oil on canvas
14 x 10 inches/35 x 25cm
Private collection, UK

79 *Stone*. 1989
oil on canvas
28 x 24 inches/70 x 60cm
Private collection, USA

80 *Wait*. 1990
oil on canvas
12 x 14 inches/30 x 35cm
Jill George Gallery, London

81 *Figure and Stone*. 1990
oil on canvas
24 x 20 inches/60 x 50cm
Jill George Gallery, London

82 *Glade*. 1990
oil on canvas
48 x 48 inches/120 x 120cm
Private collection, UK

83 *Poly*. 1990
oil on canvas
48 x 36 inches/120 x 90cm
Jill George Gallery, London

84 *Tangle*. 1990
oil on canvas
60 x 48 inches/150 x 120cm
Jill George Gallery, London

85 *Curve*. 1990
oil on canvas
18 x 16 inches/45 x 40cm
Private collection, USA

85a *Jill's Birthday*. 1989
oil on panel
48 x 36 inches/120 x 90cm
Private collection, UK

86 *Tail*. 1990
oil on canvas
48 x 36 inches/120 x 90cm
Jill George Gallery, London

87 *Boa*. 1989
oil on canvas
60 x 48 inches/150 x 120cm
Jill George Gallery, London

88 *Persephone*. 1989
oil on canvas
60 x 48 inches/150 x 120cm
Jill George Gallery, London

89 *Line*. 1991
oil on canvas
24 x 24 inches/60 x 60cm
Jill George Gallery, London

90 *Figure*. 1991
oil on canvas
48 x 36 inches/120 x 90cm
Jill George Gallery, London

91 *Stone*. 1989
oil on panel
24 x 30 inches/60 x 75cm
Jill George Gallery, London

91a *Rhino*. 1991
oil on canvas
24 x 20 inches/60 x 50cm
Jill George Gallery, London

92 *Actaeon*. 1990
oil on canvas
60 x 72 inches/150 x 180cm
Private collection, UK

93 *Cypher*. 1988
oil on panel
32 x 24 inches/80 x 60cm
Collection of the artist

94 *House*. 1989
oil on panel
12 x 18 inches/30 x 45cm
Private collection, UK

95 *Branch*. 1989.
oil on canvas
32 x 24 inches/80 x 60cm
Private collection, UK

96 *Arch*. 1990
oil on canvas
60 x 72 inches/150 x 180cm
Private collection, UK

97 *Diviner*. 1990
oil on canvas
60 x 60 inches/150 x 150cm
Jill George Gallery, London

98 *Coq*. 1991
oil on canvas
48 x 36 inches/120 x 90cm
Jill George Gallery, London

99 *Hide*. 1989
oil on canvas
60 x 48 inches/150 x 120cm
Jill George Gallery, London

100 *Box*. 1990
oil on canvas
54 x 60 inches/135 x 150cm
Private collection, UK

101 *Donkey*. 1990
oil on canvas
60 x 60 inches/150 x 150cm
Private collection, UK

102 *Holder*. 1990
oil on canvas
24 x 20 inches/60 x 50cm
Jill George Gallery, London

Frontispiece: *Self-Portrait*. 1987
oil on panel
32 x 24 inches/80 x 60cm
Newport Museum and Art Gallery, Wales

Dustjacket: *Milliner's Model*. 1983
oil on panel
14 x 12 inches/35 x 30cm
Collection of the artist.